The World of
EDWARDIANA

The World of EDWARDIANA

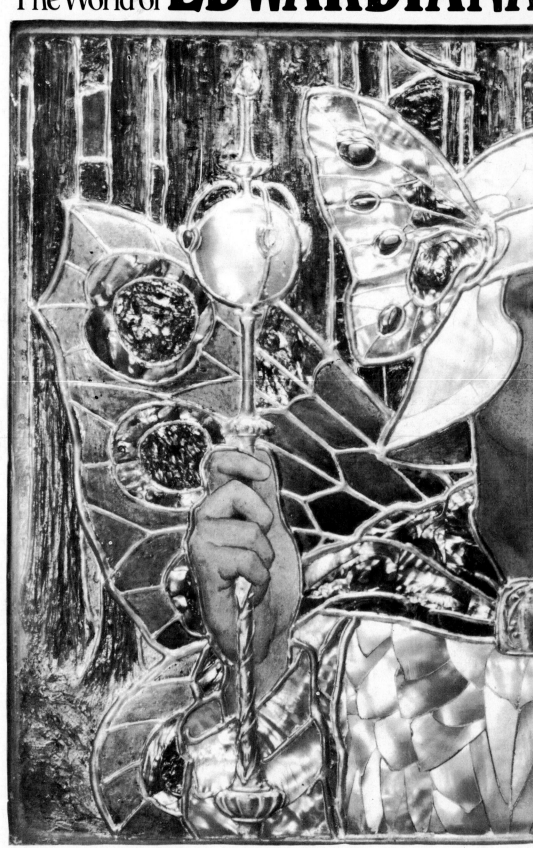

Philippe Garner

Hamlyn
London · New York
Sydney · Toronto

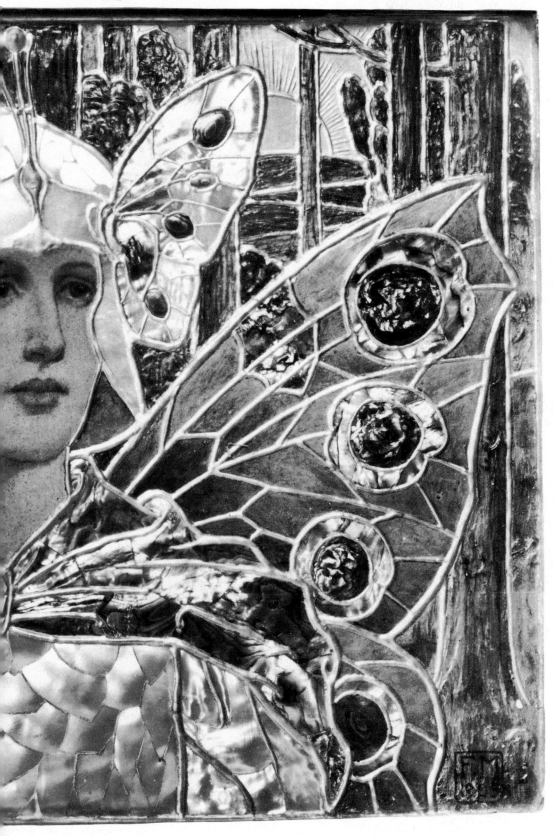

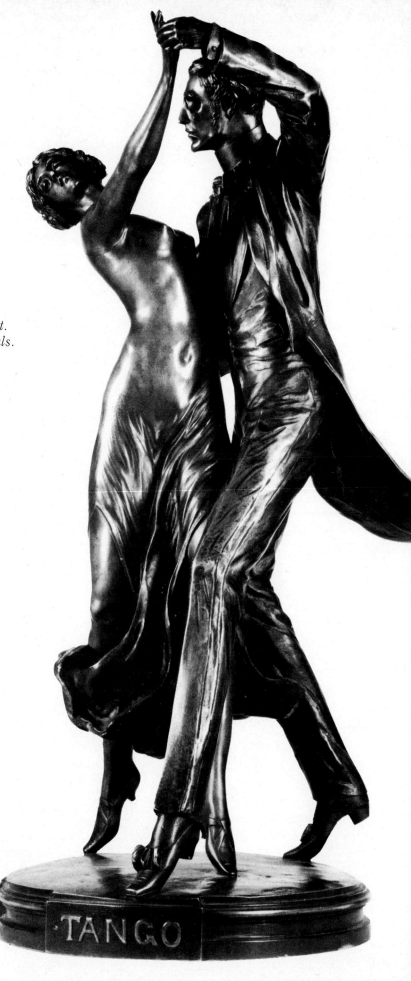

title pages
1 Oberon, *one of a pair of panels,*
Titania and Oberon, *by Frederick Marriott.*
Mother-of-Pearl, tempera, gilt gesso and opals.
Signed and dated 1905.
Sotheby & Company, London.

2 Tango, *bronze by G. Eberlein.*
German, about 1912.
Sotheby & Company, London.

Published by
The Hamlyn Publishing Group Limited
London · New York · Sydney · Toronto
Astronaut House, Feltham, Middlesex, England
© Copyright
The Hamlyn Publishing Group Limited 1974
ISBN 0 600 39273 2
Phototypeset in England by
Keyspools Ltd, Golborne, Lancashire
Printed in Spain by
Printer Industria Gráfica sa, Tuset 19
Barcelona, San Vicente dels Horts 1973
Depósito Legal B. 41134-1973
Mohn Gordon Ltd., London

MENU

MAY ·30·

1902

CHAPTER ONE
INTRODUCTION

Numbers in the margins refer to illustrations.

THERE CAN be no disputing the fact that Edward VII acceded to the throne as King of England on the death of Queen Victoria on the evening of 22nd January, 1901. There can, however, be considerable dispute on the question of when the 'Edwardian' era began. The same problem arises with the closing of the 'Edwardian' epoch. The start of the First World War makes so apt a final curtain that it would seem pedantic to notice the year 1910 for anything other than the death of Edward VII after a fairly brief reign.

The naming of a style after the monarch ruling for the duration of that style can only ever be a rough and ready measure. One can be reassured in this opinion by calling upon the evidence of paintings of, for example, Louis XV and his court most comfortably installed on Louis XVI style furniture.

For the purpose of this study the Edwardian era has been taken, roughly, as starting in 1890 and closing with the First World War.

In the field of the decorative arts little happened after 1900 for which momentum had not been built up during the 90s.

Indeed, in several instances the art movements which materialised in England in about 1900 can be traced back to the undercurrent movements of the mid nineteenth century. A clear example is the Medievalism which was part of the *avant-garde* cults of the Pre-Raphaelites, William Morris and others, and which became absorbed into the regular vernacular of decorative art by the Edwardians.

Queen Victoria was exceptional in that, by the sheer length of her reign, she was able to observe the birth, the flowering and ultimately the waning of a style that was truly her own.

It is tempting, and not unreasonable, to feel that the Victorian style owed a good deal to the character of the monarch: by the time of her Diamond Jubilee in 1897, one felt sure that her own retirement from public life had signed the death warrant of the Victorian style.

3,4 Edward was fifty-nine years old when declared King, and although by no means uninterested in art, he can only be described as conservative and perhaps unadventurous. He is quoted as having remarked, with his usual elaborate rolling of r's: 'I do not know

much about Arrrrt, but I know something about Arrrrangement.' The King's essential wariness was sarcastically expressed by Sickert in 1909: 'Sir Hugh Lane (an eminent patron of the Impressionists who secured many important works for Great Britain), has been knighted for admiring Manet; would he have been knighted for merely being Manet?'

If one were feeling malicious towards Edward VII one could almost describe the Edwardian era as 'that which isolated itself as a successor to the great Victorian age, definable only in so far as it differed from its illustrious forbear.'

John Russell, in a perceptive study of Edwardian art, states that 'Edwardian is one of Art History's unclaimed adjectives. No one name, no particular brand of artistic activity corresponds to it; art has no Elgar or Lutyens to stand beyond question for the full-blown, unhurrying, implicitly proconsular turn of mind which we call Edwardian.'

He goes on to point out, so rightly, that 'where current opinion thinks reasonably well of artists who are in fact Edwardian (Charles Rennie Mackintosh, for instance, Jacob Epstein, Walter Sickert and Augustus John), their work is often distinctly opposed to the accepted connotations of "Edwardian".'

He asks, finally, whether our native art over the years 1901—10 looks feeble and unadventurous when set beside what was going on at the time across the Channel—in Paris, in Dresden, and in Munich.

The answer is surely no! Our native achievements are in no way inadequate. The English did not indulge in the luxuriant extravagances of Continental, and especially French, Art Nouveau. But the English have always been more restrained than the French. English tastes have always been more controlled, their sophistication rather cooler, and never more so than at this period. Within the context of English art, the Edwardian age was a fertile one. To appreciate this, however, one must assume a broad outlook and take the bold step of extending the Edwardian era back to 1890 and forward to 1914. At the same time

3 *Invitation to Edward VII's coronation dinner.*
5th of July, 1902.

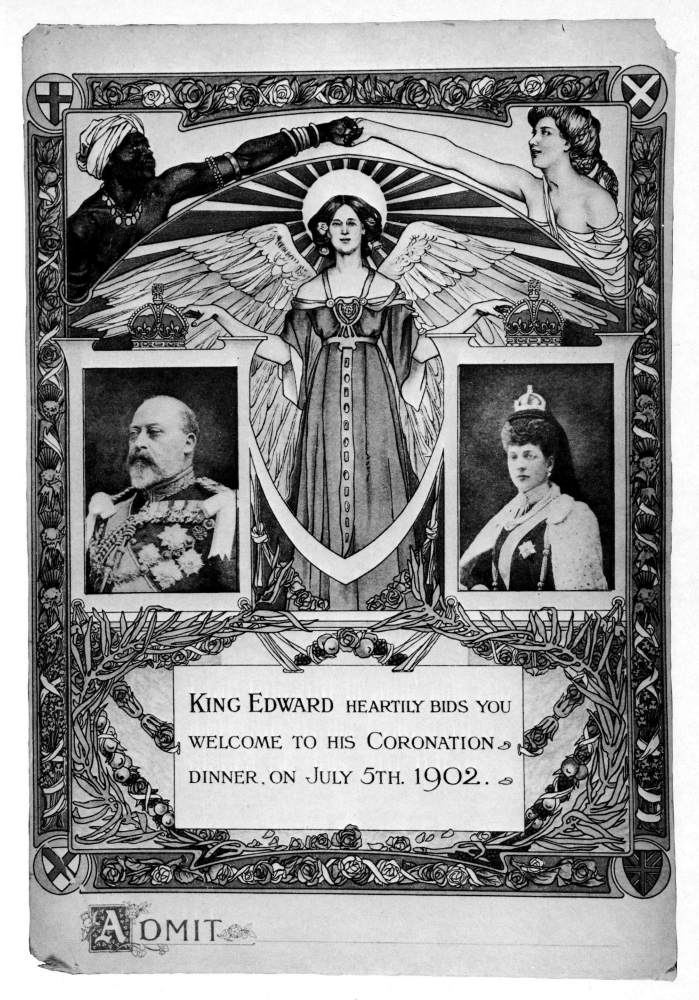

KING EDWARD HEARTILY BIDS YOU WELCOME TO HIS CORONATION DINNER, ON JULY 5TH. 1902.

ADMIT

one must dismiss the narrow 'Palm Court' image of the Edwardians as far too limiting and ultimately inaccurate and confusing.

So far no move has been made to use Edwardiana as a blanket term encompassing artistic manifestations in other countries. To maintain its identity, Edwardiana must be considered a characteristically British style, or series of styles.

The insularity of the British, and their undisguised hostility to Continental art, is typified in the following comments on *L'Art Nouveau*, taken from a discussion between eminent British artists in the *Magazine of Art,* May 1904.

'Its roots are in the squirming tree, which sprouted afresh out of the mud of the Gothic Revival' (W. D. Caroe).

'I can only express my entire inability to take such sudden apparition seriously. I fail to see in it more than a fungoid growth – if indeed an art style without parentage, and unbegotten can be said to have had growth at all' (John R. Clayton).

The most magnanimous comment was that 'I have been much attracted by it and think it good, particularly in that it shows enterprise and will probably lead to something better' (J. H. F. Bacon, A.R.A.).

Exception has been made, however, to include the American decorative arts within the sphere of this book.

On the political and social level two major points demand consideration.

First, it must be clearly established that good design, fashionable decoration and indulgence in the majority of the artefacts illustrated in this study were not the privilege of the majority of Englishmen. Britain survived on a vast structure of domestic employment, from the clerk who would employ a general maid to the aristocratic household with its army of servants, from scullery maid to butler. The distribution of material wealth was as democratic as the class structure.

The second point to consider is that the Edwardians were wealthy (i.e. the wealthy Edwardians were wealthy) with a wealth that had been earned by the Victorian generations.

By 1897, the Diamond Jubilee, Britain stood at the zenith of its greatness as a manufacturing nation, as merchant, freight carrier and banker. Overseas loans amounted to £2,300 million in solid gold coinage. An Empire of thirty-two colonies had grown to an Empire of sixty-four colonies. The lingering image of the Victorian is that of a stern-faced industrialist, a cautious, hard-working figure, the cornerstone of the solid structure that was Victorian England.

The Edwardians abandoned the solemnity of which the Victorians could be accused. As a result they could indulge their tastes for the splendid and the extravagant without scruples. Pomp and swagger are an important part of the Edwardian period.

Side by side with this splendour there existed a movement bent on simplicity, possibly a more important movement, since it was to have a more far-reaching effect on the whole of the twentieth century. The English and Scottish Art Nouveau style existed as the *avant-garde*, the 'trendy' taste, parallel with the rather more traditional 'Palm Court' style.

To appreciate Edwardiana is to understand these superficially disparate elements and to see how, taken together, they form a complete image of the age, and occasionally even meet on neutral ground.

RECURRING THEMES

The method of approaching the period so far implied has been one of broad labelling in preparation for more detailed analysis.

Another path of approach is to look at the artefacts without any pre-formed labels. After a considerable period of exposure, recurrent themes make themselves apparent. One can then explain and define broad styles in terms of such themes.

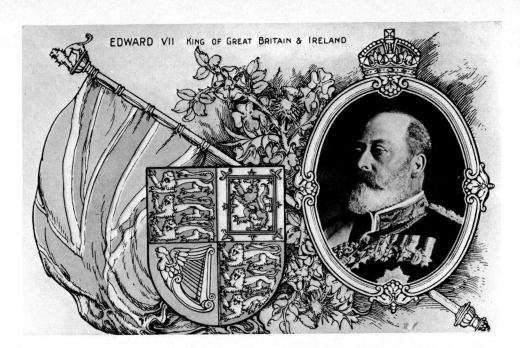

EDWARD VII King of Great Britain & Ireland

4 *Edward VII as the subject of a patriotic postcard, about 1905.*

5 *Knights tilting, by Frederick and Pickford Marriott. Gesso, tempera and mother-of-pearl, about 1902. Sotheby & Company, London.*

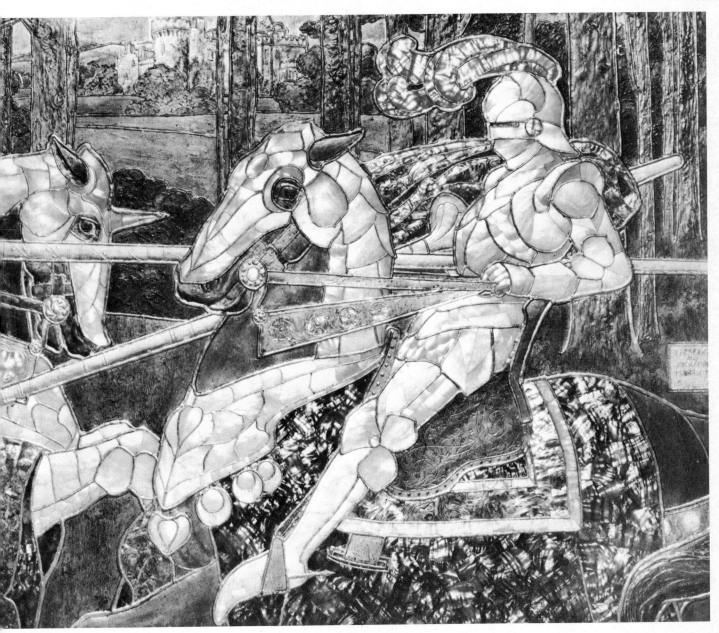

6 Titania, *one of a pair of panels,*
Titania and Oberon, *by Frederick Marriott.*
Mother-of-pearl, tempera, gilt gesso and opals.
Signed and dated 1903. Sotheby & Company, London.

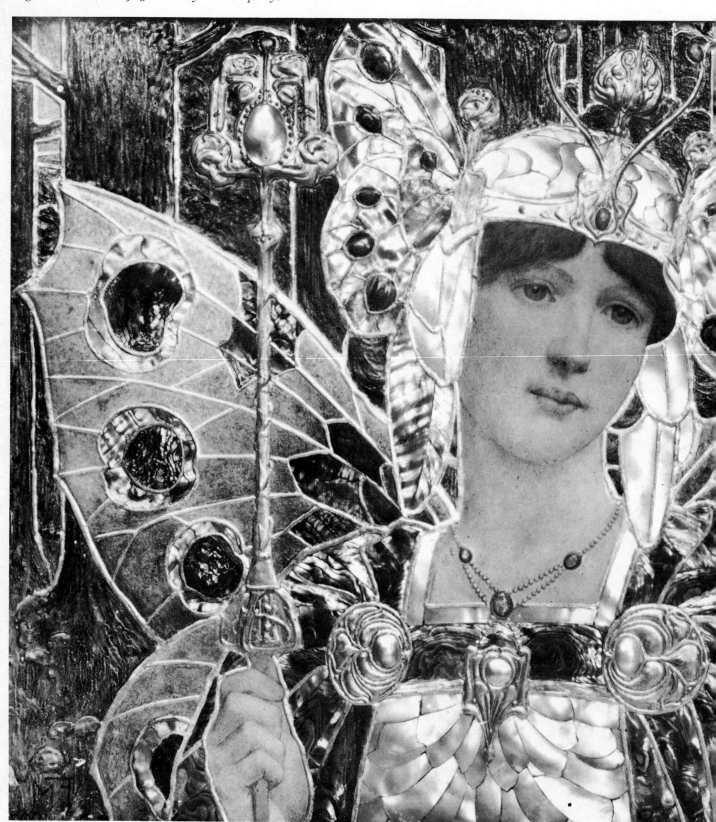

Take, for example, the theme of the Medieval 8,9,14
galleon and the related sea symbols, such as the
dolphin. The first three or four can be put down to 132,137
coincidence, but having noticed this subject on silver,
on ceramic tiles, on enamelwork, in tapestries, in
stained glass, it presents itself as a meaningful feature
in the decorative art of the period and as a key in the
puzzle of understanding the Edwardian age.

Further light is shed by the repeated use of the 5,27
Medieval knight in glorious, always victorious battle. 73,133

Clearly these references to the great Medieval age
of craftsmanship, so much admired by William
Morris, imply a romatic yearning for the wholesome
era of chivalry, for the pre-industrial years. Here is a
form of escapism. No escapism was greater than that
of the fairy story.

Just as the great Victorian fairy painters, like
Richard Dadd, had coincided with the Pre-Raphael-
ite burst of Medievalism early in the second half of
the nineteenth century, so fairy subjects, generally 1,6,62
rather tamed, were absorbed into the almost sub-
conscious language of popular art by the turn of the
century together with the galleons and the knights.

Similarly, when the peacock appears in such
diverse settings as a Beardsley illustration for
Wilde's *Salomé*, an American glass vase by Louis 10
Comfort Tiffany, an enamelled wall sconce by 125
Alexander Fisher, or a Pilkington lustreware dish, 105,7
again a pattern emerges which can be traced back to
the strong Japanese influence on the Aesthetic
movement and artists, such as Whistler, who created
his splendid blue and gold 'Peacock Room' in 1877.
Oscar Wilde recommended clusters of peacock
feathers, with their intriguing 'evil eyes', as a
domestic decoration to rival flowers.

Often an epoch expresses itself in terms of certain
colours, and this is certainly true of the Edwardian.
There was a strong taste for green, yellow and blue
either alone or in combination. Blue and green are
the *de rigeur* colours for enamel decoration on
English silver. Turquoise matrix or chrysoprase 106,107
were, inevitably, the popular stones.

The green and yellow of the 'aesthetes' was
satirised as early as 1881 by Gilbert and Sullivan in
their opera, *Patience*: '. . . Greenery, Yallery,
Grosvenor Gallery . . .'

Weight is added by the green cover to *The Studio*
magazine, the poster for *The Studio* with its maiden 98
in an ochre yellow dress on a green ground, the
Yellow Book. Again, Wilde clinches the argument 24
with his notorious green carnation buttonhole.

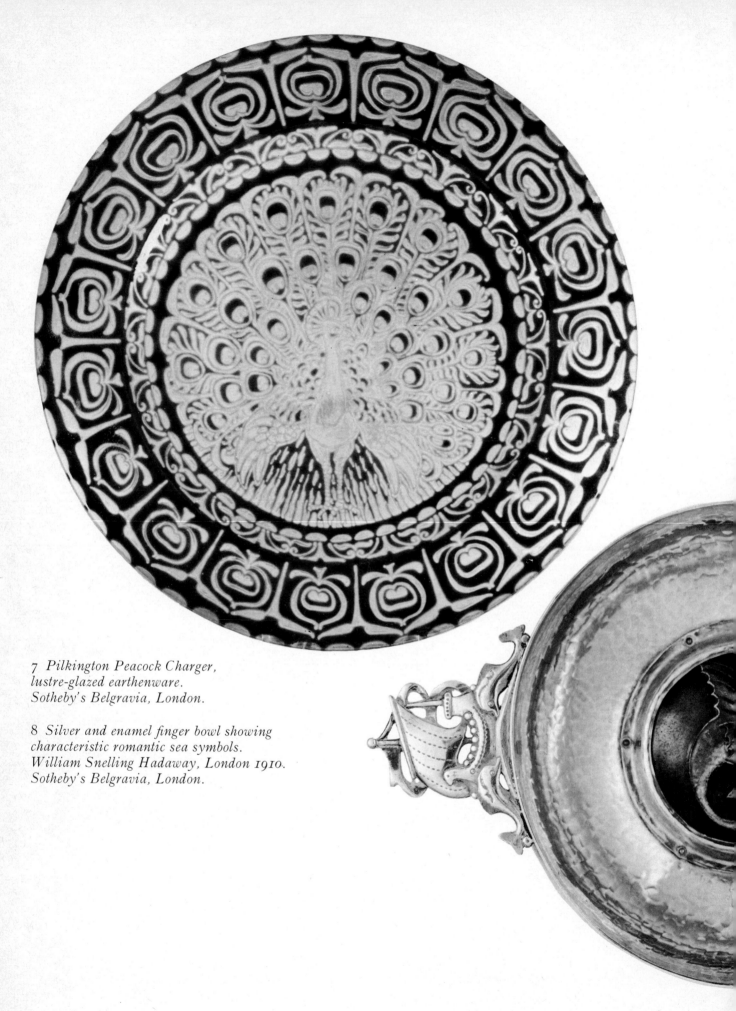

7 *Pilkington Peacock Charger,*
lustre-glazed earthenware.
Sotheby's Belgravia, London.

8 *Silver and enamel finger bowl showing*
characteristic romantic sea symbols.
William Snelling Hadaway, London 1910.
Sotheby's Belgravia, London.

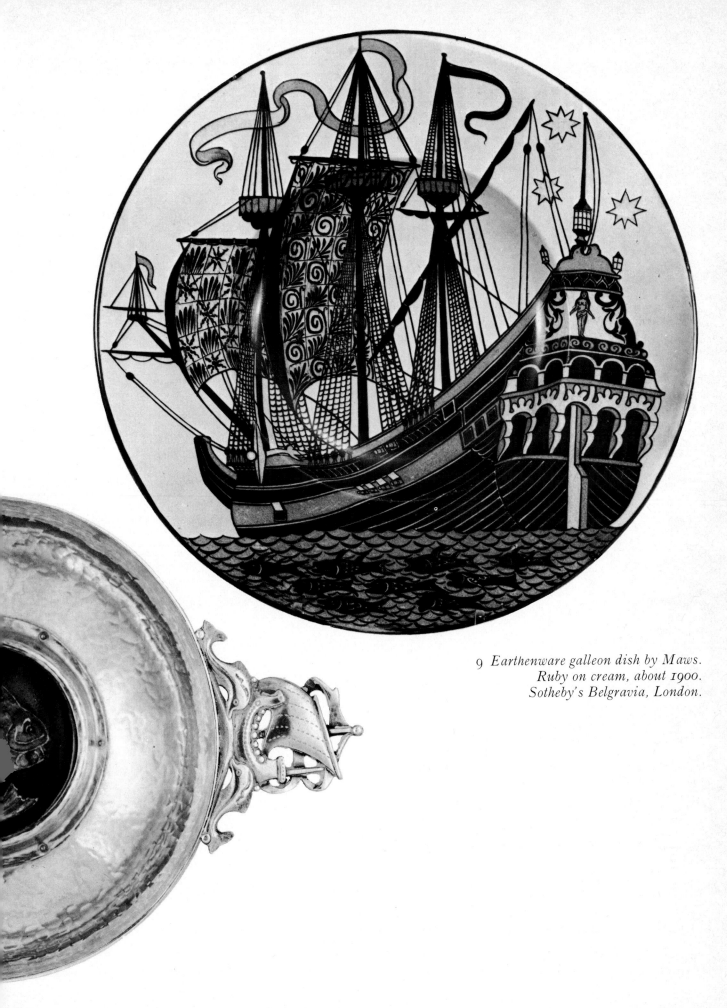

9 *Earthenware galleon dish by Maws.*
Ruby on cream, about 1900.
Sotheby's Belgravia, London.

ENGLISH AND SCOTTISH ART NOUVEAU

ART NOUVEAU developed on a spontaneously international scale, largely as a reaction to the stifling historicising tendency of the majority of nineteenth-century architects and designers. During previous centuries one style had developed out of, and followed on from, another, in a natural progression. The Victorians, however, were guilty of borrowing constantly and eclectically from previous styles. Art Nouveau came as an escape from this tendency. It was an escape for which the plans had been laid by a series of nineteenth-century theoreticians and artists starting in the 1850s.

Many found their escape route by seeking refuge in the principles of English Medieval society—the Pre-Raphaelite Brotherhood, founded in 1848, was the first to take this step. And yet this was a path of no return leading to a confused dead end. For the ideals of craftsmanship, which the nineteenth century was striving to follow, could never be reconciled with the demands of the Machine Age.

Through the second half of the nineteenth century can be traced an underground movement experimenting both with theories and in practice, attempting to find a golden mean of 'Honesty' in design.

WILLIAM MORRIS

William Morris, inspired by the 'complete degradation' which he encountered in every aspect of the decorative arts, states: 'In 1861 with the conceited courage of a young man I set myself reforming all that; and started a sort of firm for producing decorative articles.' This was in partnership with the painters, Dante Gabriel Rossetti, Ford Madox Brown and Edward Burne-Jones, the architect Philip Webb, the engineer Peter Paul Marshall, and Charles J. Faulkner, an Oxford don.

In their first circular they offered their services for mural decoration, for dwelling-houses, churches and public buildings—including carving, stained glass, metalwork, jewellery and furniture, embroidery of all kinds, stamped leather and ornamental work in other materials, besides every article necessary for domestic use.

The firm survived various setbacks, not the least of which was Morris's lack of business acumen. It survived Morris himself and the original group, and only came to a close at the outbreak of the Second World War when, on 21st May, 1940, it was placed in the hands of a receiver.

Morris's creations were by no means unattractive, and his charming wallpaper and textile designs, which are still popular today, are particularly remarkable. Their restrained arabesques, derived from plant or animal forms, have a direct appeal.

The body of Morris's work would seem far more attractive if he had not been so over-earnest. For in his extensive writings he comes across, all too clearly, as an ostrich with his head firmly buried in the sand. Morris can be quoted as wanting to see 'Art by the people, for the people'; he sets himself up as a true democrat, an artist/craftsman with a social conscience. Yet in the same breath he accepts that 'All art costs time, trouble and thought' and, one is tempted to add, money. The social reformer was creating 'Art . . . for the swinish luxury of the rich'. That Morris's art was good is not disputed. In so far as it relates to his principles, it is arguably not good. There is the constant irony also of one who abhorred any form of servile imitation and who, whilst living at the birth of the Machine Age, could cloister himself in Medievalism and declare that 'As a condition of life, production by machine is altogether an evil'.

DR CHRISTOPHER DRESSER

An anonymous article in *The Studio* of 1899 spoke of Dr Christopher Dresser as 'not the least, but perhaps the greatest of commercial designers, imposing his fantasy and invention upon the ordinary output of British industry'.

This extraordinary designer, who died in 1904, but who is so important as a pioneering talent leading up to, and working into, the Edwardian period, makes

10 *Aubrey Beardsley,* The Peacock Skirt. *From* Salomé *by Oscar Wilde, 1893.*

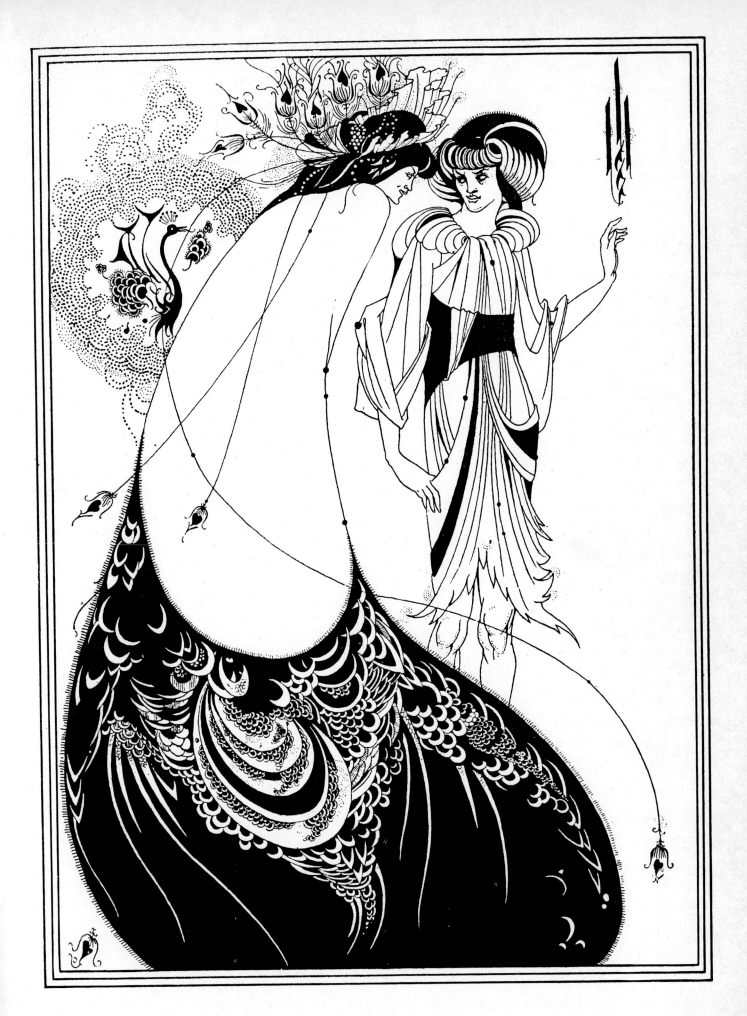

an instructive contrast with William Morris.

Whilst Morris was going far back in time for inspiration, Dresser took the path of travelling over a great distance to find a source of re-vitalisation. As early as 1862, on the occasion of the International Exhibition, Dresser was profoundly intrigued by his first major encounter with Japanese artefacts, on exhibition from the collection of Sir Rutherford Alcock. Dresser made drawings from the collection, and even managed to purchase several pieces which were to form the basis of a significant collection. In 1877 he spent about four months travelling in Japan, visiting temples and shrines and centres of traditional manufacture, and covered about 1,700 miles. He records collecting examples of Japanese goods including 'many objects for ordinary domestic use' for Tiffany and Co. of New York, who were enjoying the same pleasure of discovery. His visit was recorded in 1882 in the publication, *Japan, its Architecture, Art and Art Manufactures*.

Japan played an important part in Dresser's mature work, as indeed it did in so much *fin-de-siècle* art. The second string to his bow was his sense of the functional, derived from an innate good sense.

Dresser was possibly the first to accept positively that utility, in itself, implied beauty. He never opposed the principle of drawing inspiration from nature; he felt that the result should be an 'ideal' rather than an 'imitation'; that is, 'abstract' rather than 'figurative'.

Dresser designed silver and plate for the firms of Hukin and Heath and J. Dixon. His claret jugs with their Japanese style ebony handles, his cruets, tureens, tea services and toast racks, were produced commercially and imitated through the last twenty years of the nineteenth century.

The teapot illustrated could almost be taken for a 15 1920s design, so aggressively simple is its bold inverted conical form.

Dresser designed metalwork for various other

11 *Armchair, oak inlaid in ebony, rush seat and back panel. English or Scottish, about 1900. Victoria and Albert Museum, London.*

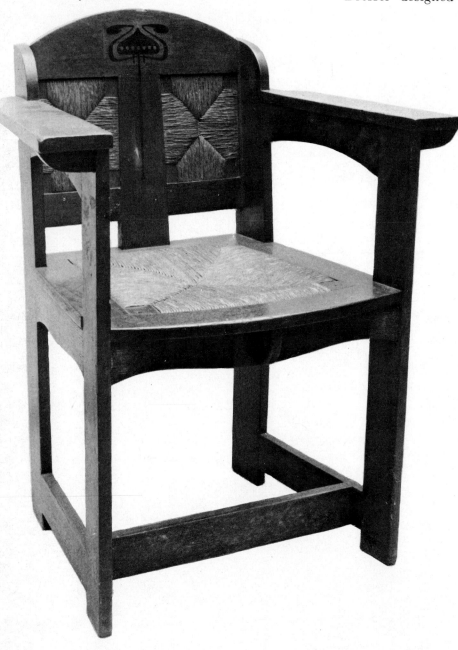

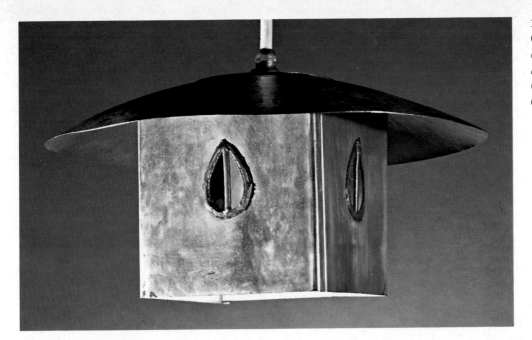

12 *Lampshade by C. R. Mackintosh, plated brass and coloured glass, about 1900. Mackintosh Collection, University of Glasgow.*

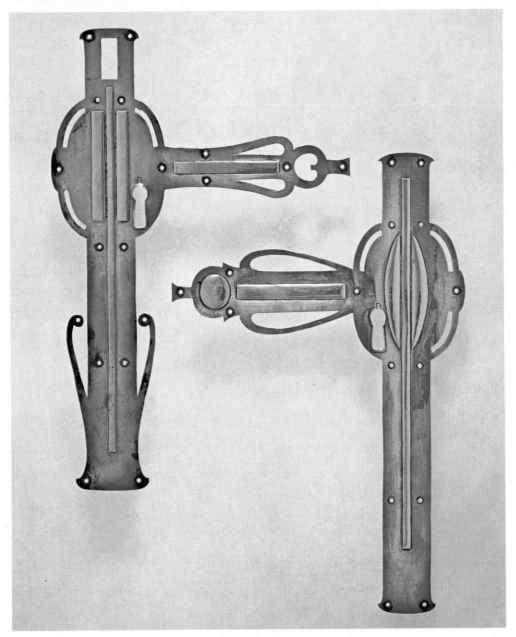

13 *Brass door handles designed for Douglas Castle, 1898. Mackintosh Collection, University of Glasgow.*

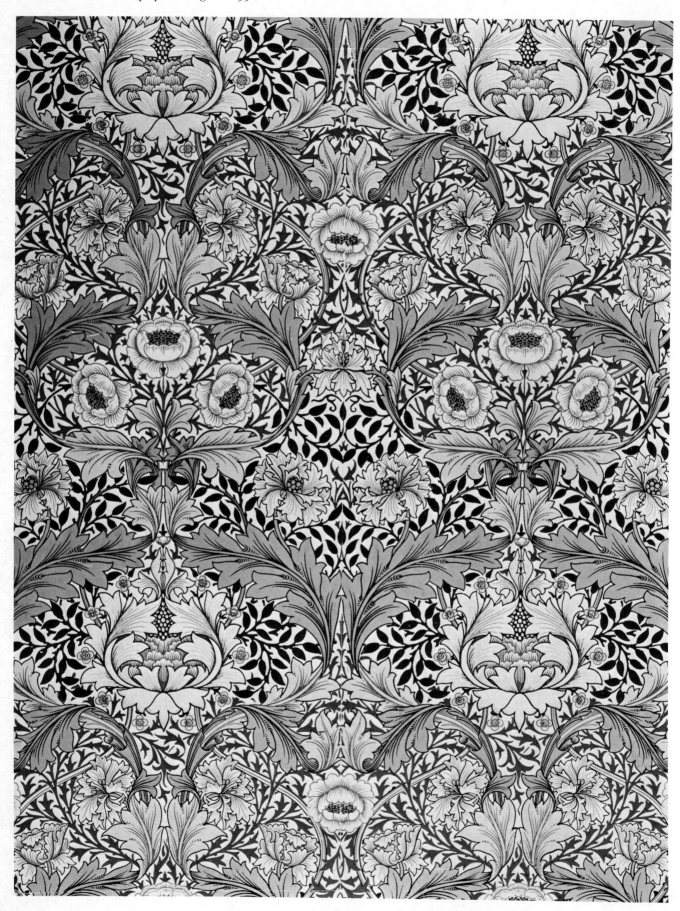

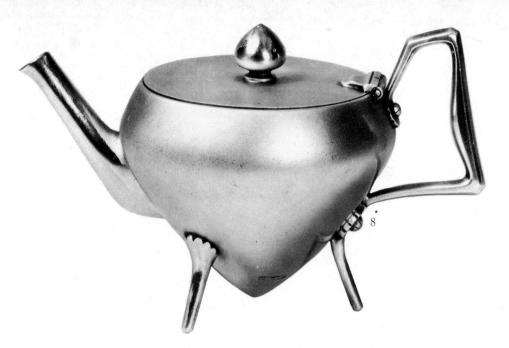

firms, pottery for Linthorpe and during the 1890s for Ault, and also during the late 90s an exciting range of glass (see pages 00–00). He is never ashamed to be the servant of industry.

III,II2

THE ARTS AND CRAFTS MOVEMENT

William Morris's enthusiasm influenced the development of a more widespread interest in the applied arts during the 1890s and 1900s. Between 1880 and 1890 five key societies had been founded for the pursuit of the ideals of craftsmanship. This was largely on the basis of his inspiration and groundwork.

In 1882, Arthur Heygate Mackmurdo created the Century Guild. Mackmurdo, a typical late nineteenth-century 'all-rounder', designed furniture, metalwork, graphics, wallpapers and textiles, as well as being a professional architect. 1884 saw the establishment of the Art Workers' Guild, with W. A. S. Benson among its founder members, and of the Home Arts and Industries Association, with a special interest in the rural. In 1888 Charles Robert Ashbee founded his Guild and School of Handicraft; in the same year there was formed the Arts and Crafts Exhibition Society, whose essential conservatism is perhaps suggested by their hostile reaction to Charles Rennie Mackintosh and his colleagues who were not invited to the Society's 1896 exhibition.

18

19

The choice of the word 'Guild' to describe these groups is worth noting, for it says as much as page upon page of their theories. The groups left themselves wide open to criticism. In 1899 a critic spoke sarcastically of their cult of the hand-made in preference to the machine-made object: ' . . . the generic feature of the physiognomy of machine-made goods as compared with the hand-wrought article is their greater perfection in workmanship and greater accuracy in the detail execution of the design. Hence it comes about that the visible imperfections of the hand-wrought goods, being honorific, are accounted

marks of superiority in point of beauty, or serviceability, or both. Hence has arisen that exaltation of the defective, of which John Ruskin and William Morris were such eager spokesmen in their time; and on this ground their propaganda of crudity and wasted effort has been taken up and carried forward since their time.'

The Arts and Crafts movement, embracing such diverse talents as Ernest Gimson, Walter Crane, the Martin Brothers, C. R. Ashbee and Benson, was responsible, however, for producing highly attractive furniture, metalwork, silverware, ceramics and glass, which will be discussed in subsequent chapters.

55,56

108

THE JAPANESE INFLUENCE

Japanese art had a pervasive influence on the Edwardian period. Examples present themselves of a Japanese influence in popular arts, like the musical comedy, where the references were very direct in character. In the work of more advanced designers, on the other hand, the principles rather than the motifs had been assimilated in an abstract way. Thus one finds a good deal of the spirit of Japanese art in the work of many 'Art Nouveau' designers, without necessarily any specific references being made. By the turn of the century designers had learnt the essential lesson from Japan. This showed itself in the economy and purity of line in Aubrey Beardsley's drawing–his Salomé drawings represent a peak of this phase–the emphasis on bold outlines and block areas of flat colour in a good deal of the graphic work, or the return to an interest in form and material in certain ceramics. There is a powerful feeling of 'japonaiserie' in certain stark, ebonised pieces of furniture by Charles Rennie Mackintosh. Similarly, one finds this in the wallpaper designs of Charles Annesley Voysey, or in his interiors, with such details as screens of vertical slats. Contemporary photographs survive of one such interior, for

10

22

16 *Decorative panel, beaten metal by*
Margaret Macdonald Mackintosh, about 1898–9.
Mackintosh Collection, University of Glasgow.

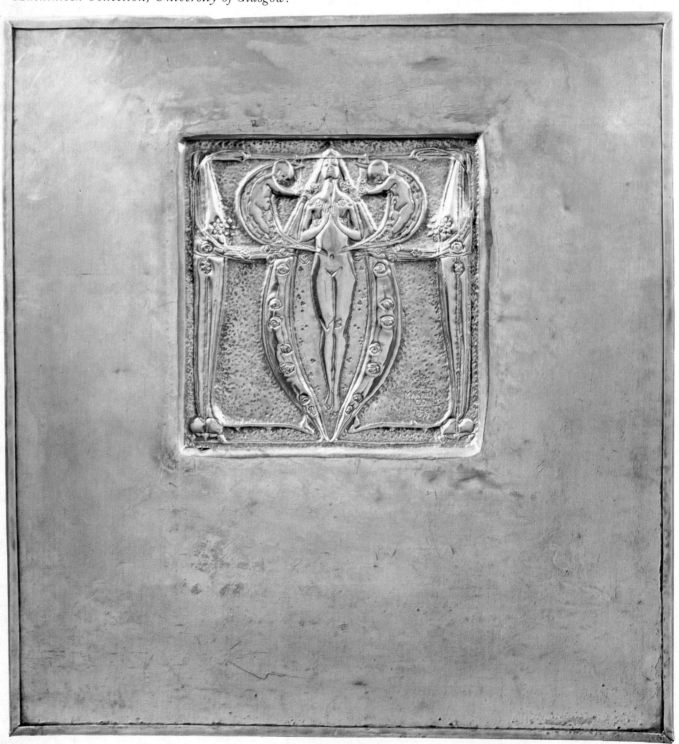

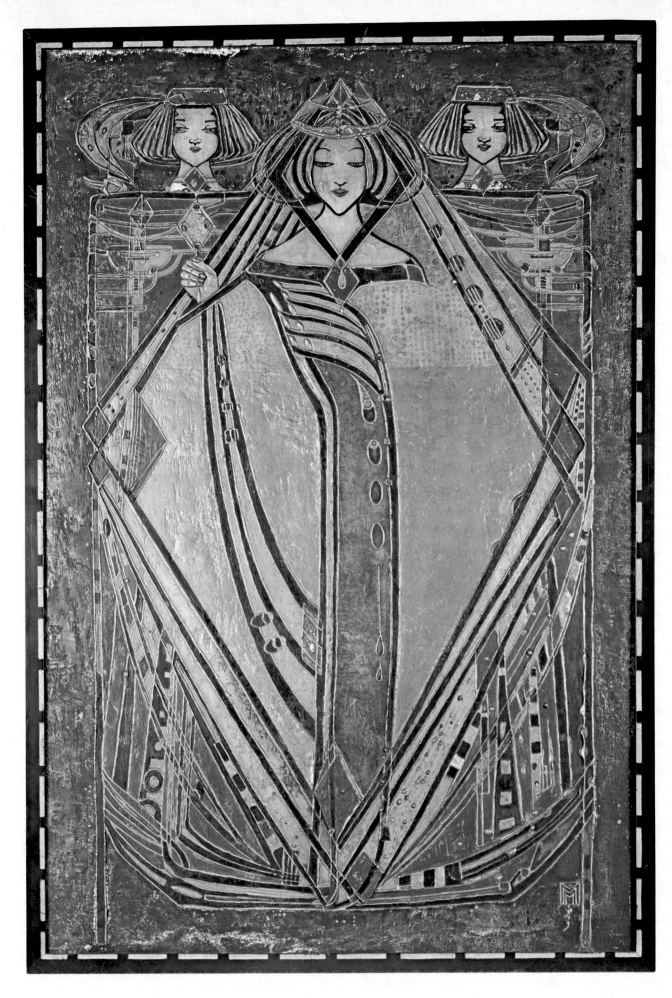

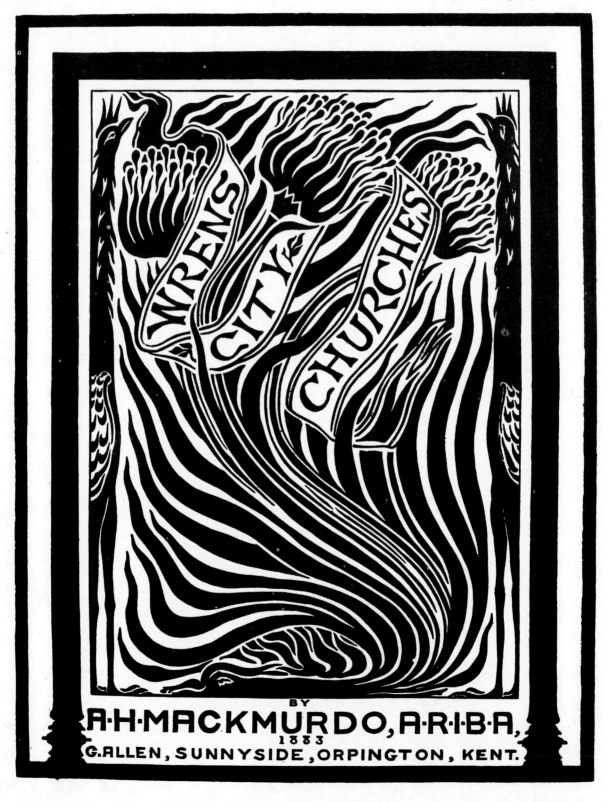

23 'The Orchard', Chorley Wood (1899), in which slender vases containing small clusters of peacock feathers can be perceived beyond the slats!

The Japanese influence in the Edwardian period could be pervasive for the very reason that it was not new to the 1890s. Japanese art had first been a novelty and a much-mocked minority taste around 1860. There are countless stories of art dealers discovering Japanese prints used as wrapping for commercial wares—these should not be taken over-seriously. The 1862 Exhibition, mentioned in context with Dr Christopher Dresser, was possibly the most critical moment. Quite apart from procuring the interest of Dr Dresser, Whistler and the Rossetti brothers, the display attracted the attention of an eighteen-year old Nottingham boy, Arthur Lasenby 34 Liberty, who had recently joined the staff of the Regent Street shop, Farmer and Rogers. Within a year, Arthur Liberty had become manager of the 'Oriental Warehouse' of Farmer and Rogers, who had bought up a good stock at the 1862 Exhibition. He was soon making important contacts as an exclusive supplier of Oriental art to the *avant-garde*. He supplied the Pre-Raphaelite artists and the backbone of the 'Aesthetic Movement', counting among his clients, Gabriel and William Rossetti, Edward Burne-Jones, William Morris, Lord Leighton, Sir John Everett Millais, Sir Lawrence Alma-Tadema, Norman Shaw, E. W. Godwin (who designed outstanding furniture in the Japanese taste) and 21 later Oscar Wilde, who proclaimed his sole ambition of living up to his blue and white china.

CHARLES RENNIE MACKINTOSH AND THE GLASGOW FOUR

Charles Rennie Mackintosh was, without exaggeration, one of the most visionary designers of the turn of the century, yet, in his time, one of the least appreciated.

His work was so undiluted in its message that the Establishment found it hard to accept.

Mackintosh studied at the Glasgow School of Art. The Principal, Francis H. Newbury, noting similar tendencies in their work, introduced Mackintosh in about 1893, together with another architecture student, Herbert MacNair, to two sisters, Margaret and Frances Macdonald. These two girls, students in the Applied Art course, learning embroidery, metal-work, jewellery and so forth, were eventually to

marry the two men. Known then as the Glasgow Four, their importance as a design team was to grow to international proportions, whilst their colleagues dismissed them as the 'Spook School', a criticism aimed at the attenuated, often morbid decorative figures incorporated into their schemes. The Viennese, in particular, appreciated and were influenced by their work.

Mackintosh's importance to the twentieth century is his ability to reduce to essentials without sacrificing sophistication. His stark highback chairs were often 50,52 criticised as being uncomfortable. This is hardly 53 important, for these are more than chairs—they are 59 a sculptural statement of design theory. By a simple interplay of horizontals with extended verticals, Mackintosh states that elaboration is no virtue, that the light shining around and the space encompassing an object are the important elements in its creation. This sense of abstract form is so powerfully expressed in the stark, yet immensely human, nature of his architecture.

Mackintosh was further important in his insistence on creating the total environment. If he were to build a tea room, then every detail down to the tea spoons 35 would come under his consideration.

The Glasgow Four (who were, incidentally, entirely responsible for rebuilding the Glasgow School of Art between 1896 and 1899) worked in many media, often as their own craftsmen, or else supervising closely. There is a spontaneous quality to their work, however, which is charming. It avoids the self-consciously 'crafted' look. They created stained 12,13 glass windows, attractive gesso panels, silverware, 16,17 jewellery, stencil work, beaten metalwork, embroidery, as well as painted or plain oak furniture to decorate Mackintosh's interiors.

The powerful, almost symbolist, quality of Mackintosh's work is beautifully suggested in a quotation from Ahlers-Hestermann and aptly drawn upon by Nikolaus Pevsner: 'Here was indeed the oddest mixture of puritanically severe forms designed for use, with a truly lyrical evaporation of all interest in usefulness. These rooms were like dreams, narrow 54 panels, grey silk, very very slender wooden shafts—verticals everywhere. Little cupboards of rectangular shape and with far projecting top cornices, smooth, not of visible frame-and-panel construction; straight, white, and serious looking as if they were young girls ready to go to their first Holy Communion—and yet

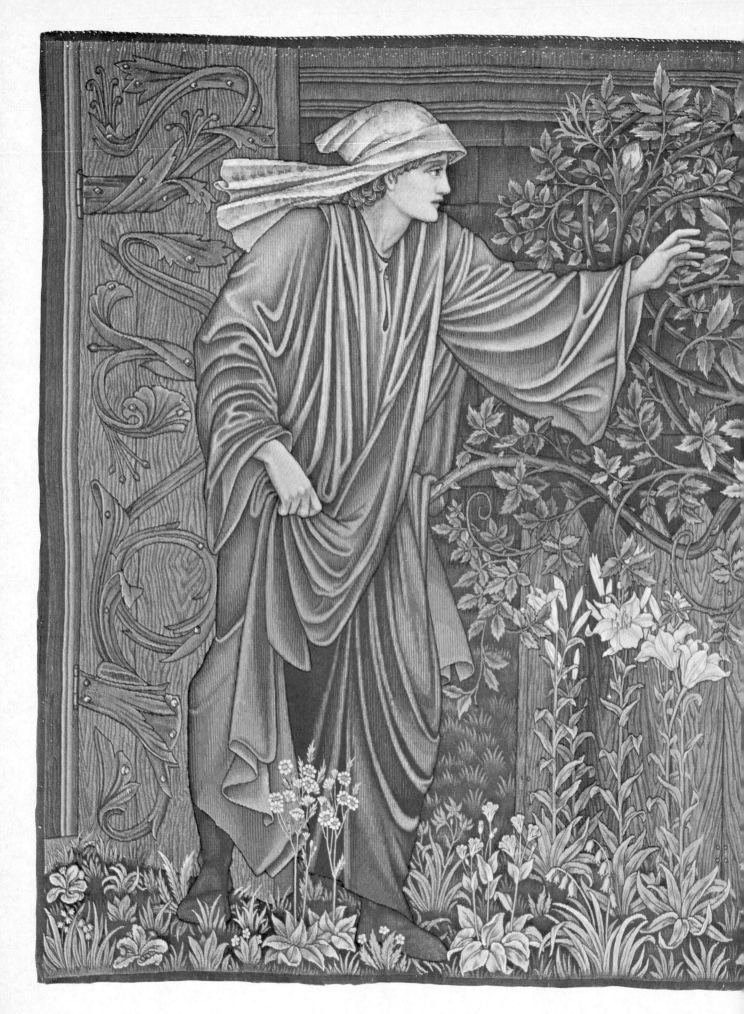

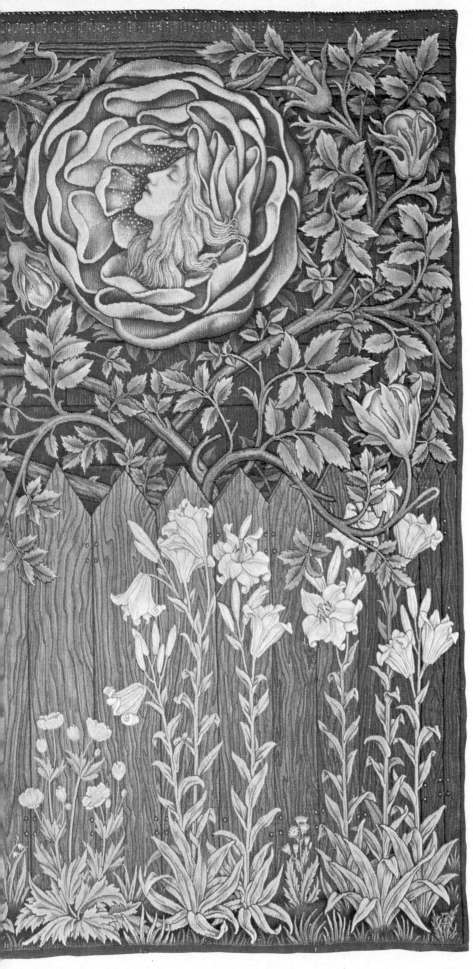

20 The Pilgrim and the Rose, *a tapestry designed by Edward Burne-Jones. Woven by Taylor, Martin and Ellis at Merton Abbey, 1901. Sotheby's Belgravia, London.*

not really; for somewhere there was a piece of decoration like a gem, never interfering with the contour, lines of hesitant elegance, like a faint distant echo of Van de Velde. The fascination of these proportions, the aristocratically effortless certainty with which an ornament of enamel, coloured glass, semi-precious stone, beaten metal was placed, fascinated the artists of Vienna who were already a little bored with the eternal solid goodness of English interiors. Here was mysticism and aestheticism, though by no means in the Christian sense, but with much of a sense of heliotrope, with well manicured hands and a delicate sensuousness . . . As against the former overcrowding, there was hardly anything in these rooms, except that, say, two straight chairs, with backs as tall as a man, stood on a white carpet and looked silently and spectrally at each other across a little table . . . "Chambres garnies pour belles ames" is what Meier-Graefe wrote.'

CHARLES ANNESLEY VOYSEY

Charles Annesley Voysey was amongst the most fashionable and popular architects of the years 1895–1903. Less extreme than Mackintosh, he nonetheless embodied the spirit of the English Art Nouveau/Arts and Crafts movement, both in the

21 *The young Oscar Wilde in an 'aesthetic' mood in 1882. Mander and Mitchenson Theatre Collection.*

23 *C. A. Voysey, the interior of 'The Orchard', Chorley Wood.*

22 The Isis, *wallpaper design by C. A. Voysey. Made by Jeffrey & Co, 1893.*

scope of his talents and in the principles which he applied to his design. For he worked in wood, metal, textile and graphic design, as well as in bricks and mortar, and always within a doctrine of truth to his materials and 'fitness' to purpose.

His architectural career began in 1874 when he was apprenticed to the architect, J. Seddon. By the time Voysey was twenty-four, in 1884, he enjoyed his own practice in Westminster. If any influence is to be acknowledged, it is that of Mackmurdo, who encouraged the young designer, teaching him to prepare designs for fabrics, wallpaper and carpets. Voysey soon earned praise as ' . . . almost the only English pattern designer who has successfully transformed natural objects into abstract repeated shapes'. It was through his two-dimensional work that Voysey first won a reputation in England and abroad, and he became a frequent international exhibitor after his first showing at the World Columbian Exhibition of 1893.

During the 1890s he built up his architectural practice, on precepts of unpretentiousness and sophistication through simplicity and soundness of concept. His work did a great deal to encourage the 'new school' of architecture, especially in America, Germany and Austria, where he was appreciated and emulated. Lack of fuss, cleanness of line, and an almost Japanese purity of spatial construction characterise Voysey at his best. Critics condemned his lack of consideration towards the clients for whom he lavished care on every domestic detail, yet to whom he allowed little freedom. Other critics spurned the 'Alice in Wonderland' character of his work. The *naïveté* of his details could be on occasion rather self-indulgent; one critic describes ' . . . fairy-tale houses having enormous roofs and practically no windows . . . heavy arches so low that an ordinary person would need to eat one of Alice's reducing cakes in order to pass under them . . . tables whose legs not only went down to the floor but sprouted upwards toward the ceiling . . . patterns made of cockyolly birds inspecting with surprise square trees slightly smaller than themselves . . .'

The Edwardian revival of a Neo-Classical style embittered Voysey who saw this as a denial of the validity of his efforts. 'We need only look at our modern public buildings . . . What do they remind us of but money, worldly power and fraud—all manner of earthly ideas.' Dispirited, he allowed his practice to decline, and by the outbreak of the First World War, Voysey was a *passé* figure, spokesman of a mood that was past.

CHAPTER THREE

THE BACKGROUND

CRITICS ARE often guilty of studying the arts in isolation from their background.

The Edwardian style was created by the Edwardian people, and it would be foolish to consider furniture, graphics, glass, pottery or any medium in isolation from the characters and the background which created them. The authors and wits of the turn of the century distil the prevalent moods and help explain certain stylistic manifestations. Similarly, the journals of the period provide invaluable source material not only showing what was in fashion, but describing the attitudes which created the fashions. The twenty or so years which this survey spans show two main phases in literary mood and thought, the evolution of two distinct fantasies. Christopher Booker, who analysed so effectively the moods of the 1950s and 60s in *The Neophiliacs*, could have transferred his phraseology to the Edwardian age. For all that is described in the expressions *'fin-de-siècle'*, 'decadence', 'the naughty '90s', can be considered as the accelerating pursuit of an image of excitement and escape. The essential unrest of the characters of the 1890s expressed itself in their neurotic, insatiable cult of the artificial. Booker describes fantasy as an 'unhappy adjustment', a manifestation of escapism, or neuroses, 'none of which can provide more than the elusive image of security because they are based only on unreal, subjective projections of the mind.' The minds of the 1890s had an insatiable thirst for sensation. Any form of perversity was lauded, vice was cultivated in spirit if not always in action, and, inevitably, heavy hints at the use of narcotics as a source of new and deeper sensations added to the restless and relentless excitement.

Oscar Wilde's Dorian Gray established the ideals: effete and aristocratic, cruelly detached from his own degeneracy, pursuing the perverse with dilettante disrespect, and treating life as a succession of fabricated poses. The oft quoted preface to *The Picture of Dorian Gray* listed a number of principles which, in their hostility to traditional codes of ethics, provide a kind of black Bible for the 1890s, an artist's antidote to the *'mal de fin-de-siècle'*. 'There is no such thing as a moral or an immoral book. Books are well written or badly written, that is all.' 'An ethical sympathy in an artist is an unpardonable mannerism of style.' 'Vice and virtue are to the artist materials of an art.'

It is typical that Dorian Gray's first love in the cycle of his evolution was for a third-rate actress. Where others saw caricatures of literary heroines, Dorian willingly visualised the purest poses, transferring his fantasy to the 'unreal' stage.

Equally typical is the cult for discovering beauty in the man-made rather than the natural. Holbrook Jackson says ' . . . it was a characteristic of the decadence not to sing the bloom of Nature but the bloom of cosmetics.' Richard le Gallienne saw the beauty of street lights, 'The iron lilies of the Strand.' Arthur Symonds sings the praises of 'Patchouli', but

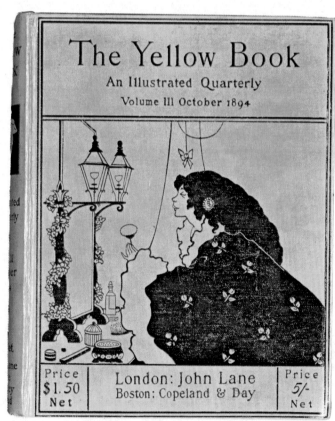

24 *Aubrey Beardsley. The cover design for the* Yellow Book, *1894. Private Collection.*

25 *'God Save the King'. Stephen and Jo Taylor Collection.*

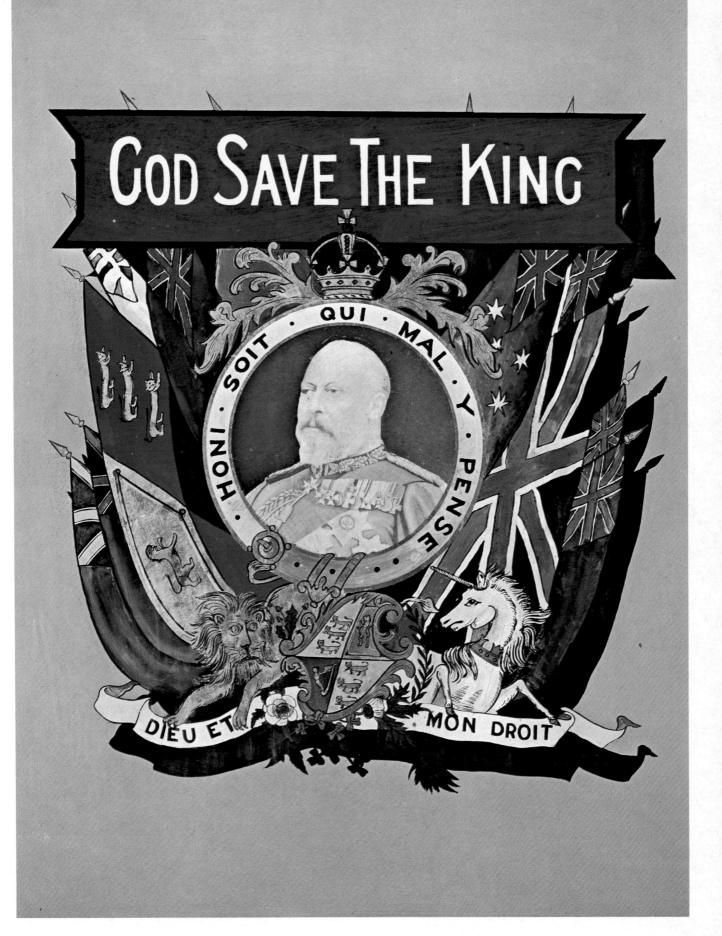

his restlessness is apparent through constant harping on the desire for 'novelty', 'change', or 'caprice'. Dandyism of dress and the use of shock as an art medium went hand in hand with this dandyism of ideas. The attack was levelled above all at complacency, but the cry of attack was its own death rattle, for any decadence is, by definition, a final phase, albeit before a phoenix-like rebirth.

The spiritual dandies of the decadence created for themselves a life style with a far reaching influence on the aesthetics of the Edwardian era, bestowing patronage, or encouraging aspiring artists, or by their precepts. An example is the fashion for green and yellow, mentioned in the Introduction. Yellow was the colour of the day, after the first appearance 24 of the *Yellow Book*, and became a symbol for all that was bizarre. Le Gallienne wrote a 'prose fancy' entitled: *The Boom in Yellow*; Colman's mustard enjoyed an unprecedented success in its advertising; we shall see the success enjoyed by Dudley Hardy's *Yellow Girl*; Arthur Benson produced an anthology of his poems and called it: *'Le Cahier Jaune'*. 30 *A Yellow Aster*, *The Green Carnation*, and *Green Fire* were other books which won sales as a result of their titles. Richard le Gallienne declared in 1896 that 'Green must always have a large following among artists and art lovers . . . an appreciation of it is a sure sign of a subtle artistic temperament. There is something not quite good, something almost sinister about it . . .'

Oscar Wilde speaks of ' . . . that curious love of green which in individuals is always the sign of subtle artistic temperament, and in nations is said to denote a laxity if not a decadence of morals'. The heightened aestheticism of the decadence is manifested in extreme examples of English or Scottish Art Nouveau, in the preciousness and the attenuation. Mr Booker could easily have described Wilde's finale, his trial and subsequent exile as the 'explosion into reality' of this personal suicidal fantasy course.

The word 'fantasy' could also define the second phase of the Edwardian period: the fantasy of 'vigour', 'virility' and 'vitality' manifesting itself at its most extreme in a blind nationalism, an exaggerated sense of imperialism, which led inexorably to its own final 'explosion into reality' with the First World War. This was the phase that demanded 29 the pomposity of a certain type of Edwardian architecture, that could admire the ideal of manhood extolled in Rudyard Kipling's *If* (how laughable this ideal must have seemed to the decadents!). This was the mood captured by Elgar, the most Edwardian of composers. His *Land of Hope and Glory* is the very essence of jingoism, his music *is* pomp and circumstance. J. B. Priestley calls weaknesses Elgar's 'brassy pomp' and 'too obvious *nobilmente*'; yet these are not personal weaknesses: they are a fundamental aspect of the age, whose moods Elgar's music expresses. Priestley, however, finds and enjoys in Elgar 'all the rich confusion of this age, the

26 *W. Graham Robertson by J. S. Sargent, 1894. The Tate Gallery, London.*

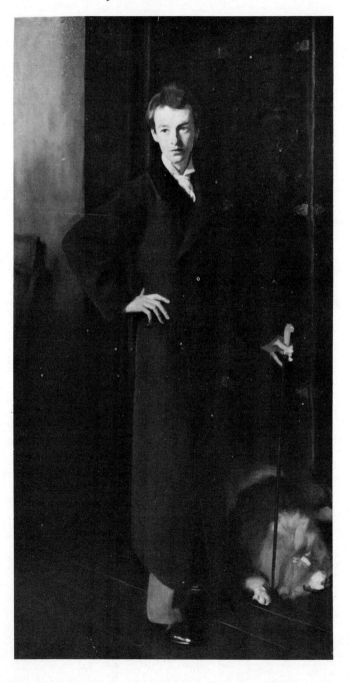

deepening doubt, the melancholy whispers from the unconscious', as a balance to the show of inflated optimism.

The self-consciously male quality at the basis of this second phase has found its exponents in such authors as H. G. Wells, Jerome K. Jerome and George Bernard Shaw, and we could perhaps find in it the source of D. H. Lawrence's gutsiness. The differences between the two moods discussed are well contrasted by Bevis Hillier, who explains how 'The Wilde scandal put an end to the old Yellow Book nonsense of floppy bow ties and hyacinthine locks. This was the age of the stiff upper lip. Men's collars became white manacles, and their hair was cropped with a penitentiary zeal.'

AUBREY BEARDSLEY

Aubrey Beardsley's art condenses within the brief span of his working years many of the aesthetic influences of his period; within his work can be found a microcosm of the many façades of turn-of-the-century art. It would perhaps be unjust to describe his stylistic changes as an evolution – that this talent could turn from Medievalism to a pure *japonaiserie* to an elaborate eighteenth-century style is explained more by a nagging restlessness than by a constructive attitude of progression. In Beardsley's art the constant shift of style is the action of a neurotic mind feverishly demanding a new focus for its dreams.

Beardsley was born in Brighton in 1872, and he spent his brief life under the threat of consumption, diagnosed as early as 1879. The start of his fame coincided with his coming of age; it was in 1893 that appeared the first instalments of his *Le Morte d'Arthur*. His name reached a wide public when

27 *Aubrey Beardsley,* Medieval Knights. *Decorative design for the* Morte d'Arthur, *1893. Private Collection.*

28 *Aubrey Beardsley,* Rambling Rose. *Borderwork design for the* Morte d'Arthur, *1893. Private Collection.*

REPRODUCTIONS OF ELEVEN DESIGNS OMITTED FROM THE FIRST EDITION OF LE MORTE DARTHUR ILLUSTRATED BY AUBREY BEARDSLEY AND PUBLISHED IN MDCCCXCIII ALSO THOSE MADE FOR THE COVERS OF THE ISSUE IN PARTS AND A FACSIMILE PRINT OF THE MERLIN DRAWING

WITH A FOREWORD BY AYMER VALLANCE AND A NOTE ON THE OMITTED DESIGNS BY RAINFORTH ARMITAGE WALKER, PRINTED AT EDINBURGH BY TURNBULL AND SPEARS, AND PUBLISHED AT ALDINE HOUSE LONDON BY J. M. DENT & SONS LIMITED MCMXXVII

27

28

A List of Contents

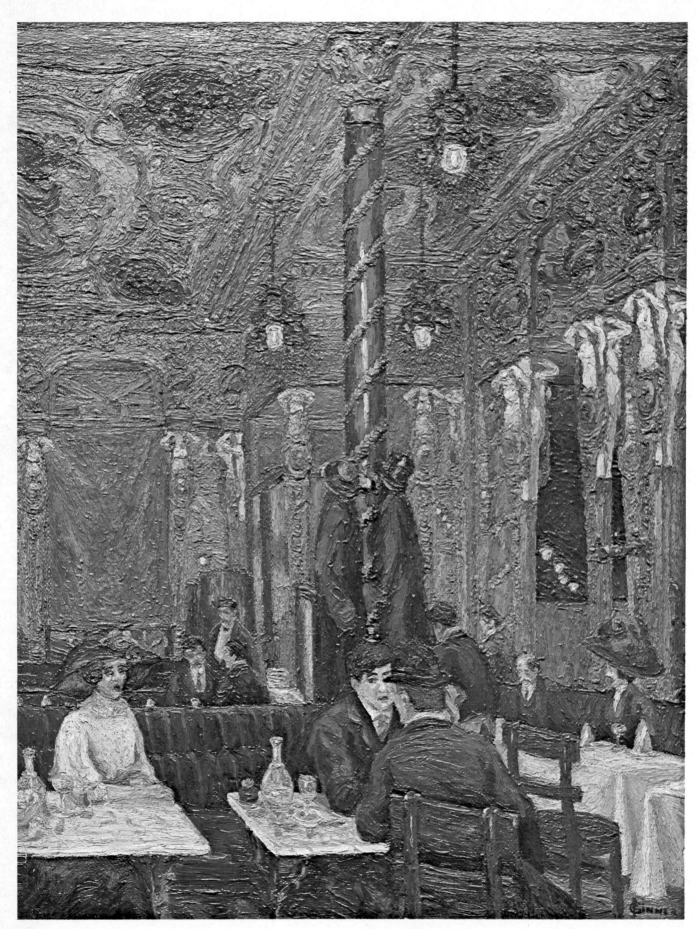

Joseph Pennell wrote an illustrated article on him in the first number of *The Studio* in April, 1893. The article 'A New Illustrator' launched this *enfant terrible*, who was to lend his name to the brief era which he spanned. For after merely five years of work Beardsley died of tuberculosis in Menton on 16th March, 1898. Beardsley's notoriety, if not fame, was assured after his invitation to design a series of 24 covers for the *Yellow Book* in 1894, and by his links with Wilde through his illustrations for Wilde's *Salomé* (though many omit to emphasise that Beardsley spitefully caricatured Wilde as the Woman in the Moon, or as grotesques in these drawings).

Two aspects of Beardsley's work in particular have a relevance in the broad context of this study. First is the marked influence of the Medievalism propagated first by the Pre-Raphaelites and then by exponents of the Arts and Crafts movement. Beardsley never disguises his admiration for Burne-27,28 Jones, and his *Morte d'Arthur* illustrations mark the high point of this phase. Romantic and chivalrous knights enact an idealism within stylised rambling rose and thorn branch borders. The second aspect is that stark, semi-abstract phase, in which the 10 *Salomé* drawings mark the high point, hailed by many as Beardsley's most modern style for the refinement it absorbs from Japanese art, for its elegant technique of graphic shorthand, and for its uncompromising exploitation of line and block area to define form, depth or tonality. With this style, Beardsley was perhaps at his peak, for it was his least literary phase, and the interest is focused very directly on the analysis of form. Yet he found it easy to explore his own moods further, was able, perhaps compelled, to advance into a mock eighteenth-century dream style in which his complex and often confused literary symbolism burdens the succinctness of line which our own generation considers as Beardsley's greatest virtue.

THE STUDIO

The most powerful vehicle for the propagation of new artistic ideas during the Edwardian era was *The Studio*, an 'Illustrated Magazine of Fine and Applied Art'. Founded in 1893 by Charles Holme and Lewis Hind, its aim was to raise standards of aesthetic sensibility on the broadest possible level. Though concerned with every aspect of the arts, its greatest single contribution was perhaps in graphic art.

New technical possibilities in printing were promoted and exploited within its pages, and its own wealth of photographic and graphic illustration was a source of encouragement and reference. Artists in Europe and in America, as well as in England, acknowledge their debt. Bill Bradley was greatly inspired by Beardsley's work, encountered through its pages. *The Studio* carried far and wide the reputations of the best British artists and craftsmen of the age, and today provides a fertile reference library in itself for the study of Edwardian art.

30 The Green Carnation.
This book won sales as a result of its title,
green symbolising decadence.
Mander and Mitchenson Theatre Collection.

THE BOOM OF THE DEPARTMENT STORES

WITH THE industrial growth of the nineteenth century, a new class was emerging with spending power, while this same industrial growth meant that an ever-increasing range of goods could be provided to satisfy this new market. Industrial prosperity changed the pattern of the retail market, creating simultaneous growth in both supply and demand.

This expanding market encouraged shopkeepers to extend their field of activities. No longer needing to rely on a small *clientèle*, many refused to offer traditional credit facilities, providing instead a wider choice of merchandise at competitive prices for cash purchase. The more adventurous opened workshops or factories, cutting costs by becoming their own manufacturers, the more successful lent their names to the great stores that are household words today. The Victorian age saw the birth and growth of the department store, the Edwardian age saw its zenith.

The great Edwardian age of leisurely complacency was well pandered to by the department stores which were at their very peak at this time. For the personal nature of the service provided was an attractive heritage from the age of the private tradesman, whilst the stores themselves had learnt to be as grand and complacent as their clients. Far away was the cut-throat competition, the ruthless undercutting and high-powered advertising of today. There was a gentlemanly quality to the stores, and rivalry or internal competition maintained a high level of politeness and gentility. When, for instance, the American, Gordon Selfridge, opened his store in Oxford Street in 1909 and celebrated the occasion with an army trumpeter blowing a fanfare from the parapet which shrouded the main entrance, Harrods countered by holding a series of Jubilee concerts during the same week, with Landon Ronald conducting the London Symphony Orchestra. Open hostility went no further than Mr Selfridge's admiring 'this . . . magnificent counterblast to our opening.'

During the Edwardian age, the department stores enjoyed an ideal compromise between grandeur and intimacy. For, however extensive the range of goods offered, however large and imposing the store buildings were becoming (Debenham and Freebody, for example, was rebuilt on a truly palatial scale in 1907), a personal note was retained. Sales staff and doormen knew the majority of their customers and were rigorous in the practice of addressing them by name. The Army and Navy Stores was based on a system of membership and boasted that a member would always be addressed by name, even after an absence of several years. Prestige was maintained by a cult of snobbery, and this was in no uncertain terms, as can be seen in the discontent registered by the Army and Navy in the Special Notes introducing their catalogue: 'Complaints have been made of persons entering the Stores to make purchases who are not Members, and who are not of cleanly appearance and respectably clad. Members will oblige by making their own personal purchases and by not sending servants or messengers for them.' Children were frowned upon and so were dogs. Harrods did not forbid dogs (how un-British this would have seemed!). It was simply made clear that accommodation could be found for them by the entrance whilst their masters shopped.

What stands out above all as the greatest attraction of the Edwardian department store was its club atmosphere. Osbert Lancaster explains:

'It is difficult nowadays to realise how very personal was then the relationship, even in London, between shopkeeper and customer and the enormous importance, comparable almost to that attained by rival churches, which late Victorian and Edwardian ladies attached to certain stores . . . for my great aunt Bessie, the Army and Navy Stores fulfilled all the functions of her husband's club, and her undeviating loyalty was repaid by a respect and consideration which bore little or no relation to the size of her account.' At the time of its 1909 Jubilee, Harrods was justifiably described as 'a recognised social rendezvous, acknowledged and patronised by Society [the capital 'S' is as obligatory as was the capital 'M' for Member in the quote from the Army and Navy's catalogue] . . . elegant and restful waiting and retiring rooms for

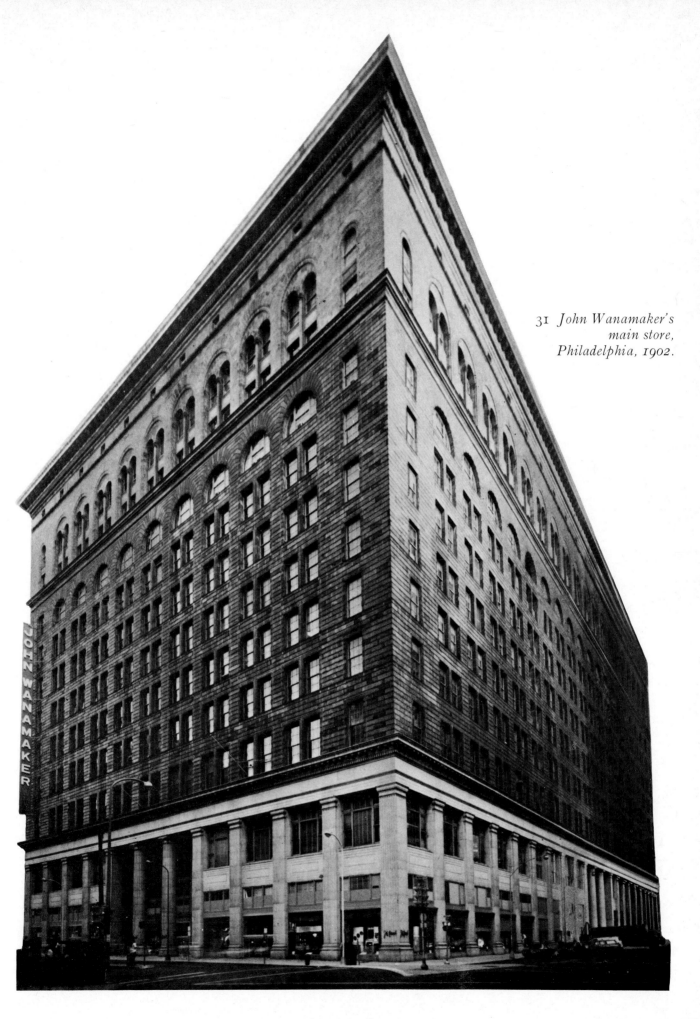

31 *John Wanamaker's main store, Philadelphia, 1902.*

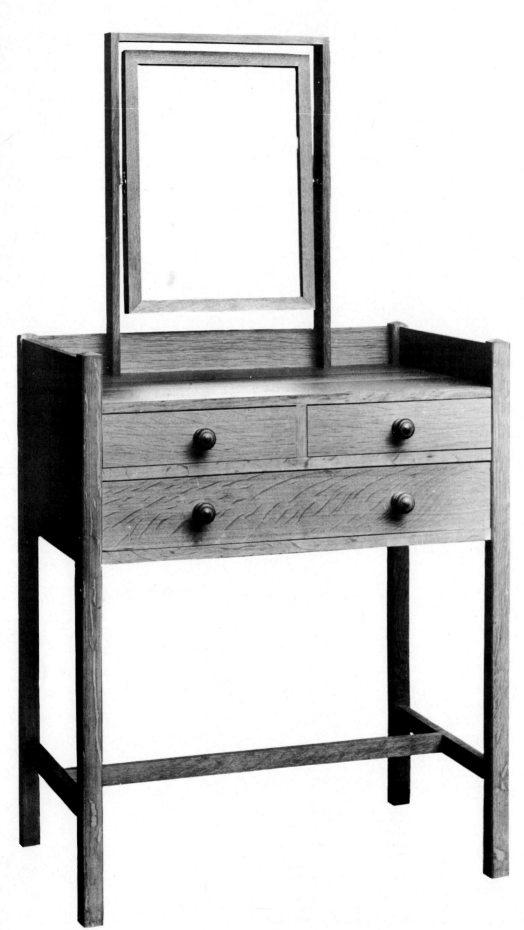

32 *Dressing-table in unpolished oak designed by Ambrose Heal, about 1910. Heal & Son Ltd, London.*

33 *Sideboard in unpolished oak designed by Ambrose Heal, 1906. Heal & Son Ltd, London.*

both sexes, writing rooms with dainty stationery, club rooms, sitting rooms, smoking rooms, etc., free of charge or question, public telephones in all departments.' Harrods' deliberate and extravagant use of vast, open carpeted areas of unexploited selling space, further helped in disguising the essential business of selling behind a façade of leisure. The leisurely pace must have been ruffled just a little, even for the blasé Edwardian generation, by the introduction in 1898 of an 'electric staircase', a kind of magic carpet into the cossetted dream environment of the Grand Emporium.

The Army and Navy, so representative of the Edwardian age, had more than the feeling of a club – it was a genuine 'Members Only' establishment. Founded in 1871 by a group of army and navy officers as the Army and Naval Co-operative Society, its original function was to reduce the cost of wine by buying in bulk wholesale. Membership, costing 5/- the first year, then 2/6d. annually, was restricted to officers, N.C.O.'s, their families and friends. The list of people eligible for membership was slowly extended, though it was not until 1922 that membership tickets were issued free and without introduction. The Civil Service Stores have a comparable history, having been founded some six years before by Post Office clerks in an endeavour to beat the rising cost of tea.

What better place than the Army and Navy Stores to observe the buying habits of imperialist Edwardians, or indeed of Indian Princes, for in 1901 branches were opened in Bombay, Delhi, Calcutta and Karachi, and catalogues were issued with price lists in Indian currency. The page of the catalogue dealing with hats is an education in itself: 'The Viceroy' at 17/6d., 'The Colonial' at 10/6d., 'White drill and khaki canvas Shikar helmet' at 13/6d. or the 'Cawnpore Tent Club' pith hat at 14/6d. Colonial

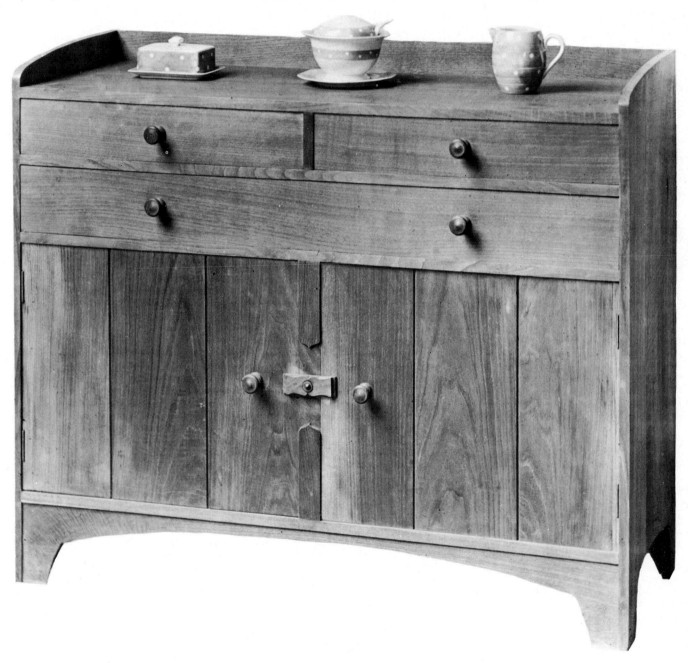

chairs and other furnishings in cane or bamboo were clearly very popular. One could choose from a range of Malacca cane chairs between 10/- and 12/-, cane or bamboo chaises longues between about 25/- and 40/-, or could opt for the slightly more expensive 'Watherston' chair, 'a perfected pattern of the Old Indian chair, specially made for hard wear and for tropical climates', made in ash, brass and green canvas and retailed in 1907 at 51/-.

The image is very much one of tradition and conservatism, of stores bending over backwards in their efforts to satisfy the dictates of their clients. There were exceptions, however, and two stores deserve special attention for their independence of approach. Liberty and Co. created fashion and expected their customers to adopt the styles they promoted; Heal's were very design-conscious and, like Liberty's, offered a kind of patronage to talented young designers.

Heal's took its name from its founder, John Harris Heal, and was in its infancy at the time of Charles Dickens' first novels. During the 1850s and 60s, the firm expanded on its present site in Tottenham Court Road as a prosperous furnishing retailer. It was the fourth generation that was to give the 32,33 business its artistic bias. Ambrose Heal Junior, after serving a period of training as a cabinet-maker in Warwick, joined the firm in 1893. He was sympathetic to the spirit of the Arts and Crafts movement, and started to design oak furniture in simple forms, issuing his first *Catalogue of Plain Oak Furniture* in 1898. He put examples on show at the Arts and Crafts Society exhibitions, and the freshness of his work started a considerable following. His own salesmen, apparently, found it difficult to acclimatise themselves to the simplicity of line advocated by Ambrose Heal, and dubbed his designs 'prison furniture'. Sir Gordon Russell, however, maintained that Heal ' . . . was perhaps the only man in the retail furniture trade of that time who had any real interest in and knowledge of design', and it is amusing to consider that more conservative business rivals saw him as ' . . . a long-haired chap with odd notions.'

Especially amusing is the thought that, where one now gazes at the vast, stable edifice of Liberty & Co. of Regent Street, there was originally a small, *avant-garde*, trend-setting 'boutique'. We have seen 34 how Arthur Lasenby Liberty encountered the art of Japan at just the right moment. From his opening in 1875 with a staff of two until his semi-retirement from business around 1905, his shop enjoyed a tremendous success which thrived on the loyalty of his clients, and equally on the spitefulness of cartoonists who jibed at him with such remarks as: 'Oh, Liberty,

Liberty, what crimes are committed in thy name!' Liberty was shrewd in capitalising on his position as provider to the 'Aesthetic movement', for as his fame and fortune grew, he was able to profitably pursue ideas of his own, lending his name to perhaps the most elegant English interpretation of Art Nouveau. Of particular merit was the 'Cymric' range 104 of silver which will be discussed in a subsequent chapter. The popularity of this silver induced Liberty to launch a range of similar designs (in pewter) under the name 'Tudric' to reach a wider public.

The ventures made by Liberty in the field of printed fabrics have, more than anything, secured the shop's reputation. 'Liberty' print has become almost the generic term for a certain type of richly printed silk or 'Tana' lawn. The name 'Tana', incidentally, derives from the original cost of this cloth per yard, 6d. or 'a tanner'.

In the United States of America, the boom of the department store well demonstrated the open vitality of the American nature – there was no unnecessary subtlety or subterfuge, nor was advertising considered sordid. A jovial brashness and a sense of showmanship helped establish many an American reputation – to provide 'The Biggest', to be always 'The First' were the measures of success. The study of the growth of any one of several American stores would show this attitude in microcosm. John Wanamaker's 31 store in Philadelphia provides a good example.

He opened in 1861 and took $24.67 on his first day. Bravely he invested the $24.00 in a newspaper advertisement, keeping only the cents as a float. He can justifiably be described as one of the fathers of modern advertising, and he thought nothing of such publicity stunts as building a life-sized copy of the Rue de la Paix (1896). He was the first to organise the presentation of Paris and Berlin fashions in the United States of America, the first to light his store with electricity, and the first to instal the new Bell telephone system. The first private branch exchange was installed in Wanamaker's store in the autumn of 1900. His store kept bursting at the seams until the construction of the present building was undertaken in 1902, an early exercise in the new skyscraping steel-framed structures pioneered by Sullivan with his Wainwright Building, St Louis, 1890–1. The death of Edward VII provided Wanamaker with a further opportunity to snatch a 'First'. Motion pictures and photographs of the King's funeral in 1910 were rushed to America by fast steamer and were shown in Wanamaker's Egyptian Hall a week before any other moving picture of the event was shown in America.

ARCHITECTURE AND INTERIORS

THE BRIEF pen sketches of the two schools of Edwardian architecture made by Sir John Betjeman in his various writings on the period convey, far more succinctly than could any stylistic analysis, the qualities of the two poles of Edwardian architecture. He approaches the buildings through the life styles of the architects who created them, and conjures up a vivid impression: 'There were two sorts of Edwardian architect, the tweedy and silk-hatted. The tweedy were the followers of William Morris and the Art Workers' Guild. They wore ties in a gold ring and saxe-blue shirts. They liked to live in the country and they enjoyed carpentry, joinery, blacksmith's work and doing water colours.' Their Bible, he adds, was *The Studio*. 'The [second] group was associated with the Royal Academy, Country Life and the Architectural Review.' This last group was responsible for all that was inflated and ostentatious in Edwardian architecture, for the brazen use of rich materials and for grand display. These were the ingredients of the flamboyant style which Betjeman clearly favours, though he rightly acknowledges the more lasting qualities of the soft-hatted brigade who revolutionised middle-class domestic architecture.

Another critic, Nikolaus Pevsner, in his *Pioneers of Modern Design*, is openly scathing about those same architects whom John Betjeman singles out for admiration. He laments that '... at the very moment when continental architects discovered the elements of a genuine style for the future in English building and English crafts, England herself receded into an eclectic Neo-Classicism with hardly any bearing on present day problems. For country houses and town houses Neo-Georgian or Neo-Colonial became popular; in public buildings, banks and so on, solemn rows of colossal columns re-appeared, not entirely free from the influence of the United States, where ... a similar reaction ... had set in.' He cites the Selfridge building of 1908, by the Chicago firm of Burnham & Co., as an example of this tendency at its most demonstrative.

Yet the title of Mr Pevsner's book explains his bias and, in all fairness, one should not consider the grand Edwardian style in relation to the descendants of William Morris. It is a style which stands outside the mainstream evolution towards 'modern design'. In describing the extravagances and self-indulgence of the style, one must accept that its success lies in an ability to push 'good taste' to the limits. Indeed, if one is completely honest, one should say that the limits of good taste were unashamedly exceeded, often to the point of vulgarity. And in this vulgarity can be found a justification of, and explanation for, eclecticism, for Edwardian architecture shows the signs of an energetic, and not a sterile, eclecticism.

The sombre Gothic of the Victorians was anathema to the Edwardian generation. As we have seen, this was a second generation of wealth and, in the tradition of privileged offspring, very few scruples were shown in the lavishing of this wealth on display. The vanity and self-importance of Edwardian architecture provides a welcome breath of fresh air, or at least a change of air, after the sternness of the Victorian period. Architectural trainees, brought up to revere the Gothic, reacted violently to this with their enthusiastic re-discovery of the Renaissance style. On sketching tours abroad, they would soon finish with the Gothic cathedrals of Northern France to immerse themselves in the masterpieces of Renaissance architecture or in the splendours of Italian, Austrian or German Baroque. Inigo Jones and Sir Christopher Wren were inevitable heroes to this generation which hoped to exploit the possibilities of such innovations as steel structuring to create monuments on a scale far grander than their predecessors had dared. This is not to imply that Edwardian architects were showman engineers bent on prodigious displays of technical expertise. They were not. Steel was a means to an end and would never be bared with pride but, on the contrary, totally disguised. Similarly, this breed of architects was in no way a breed of social planners. Theirs was a

35 *Charles Rennie Mackintosh. Buchanan Street Tea Room, Glasgow, 1897–8.*

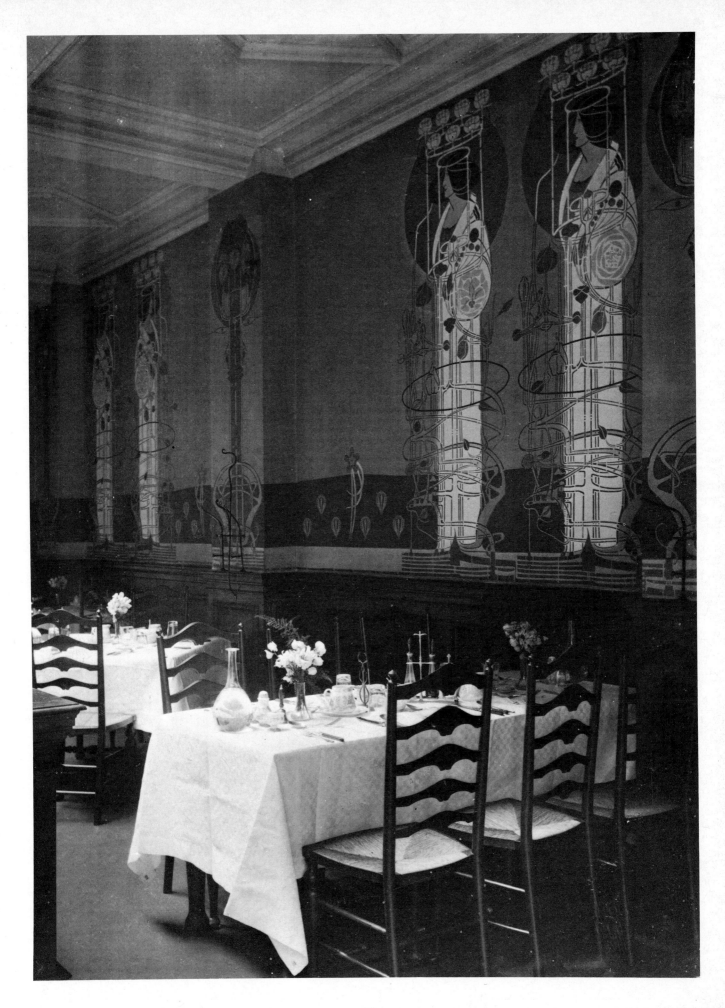

gentleman's profession and their sole devotion was to the duty of pandering to 'gentlemen' clients. The Edwardian age was the last to witness the erection of grand country houses, and similarly we have not since seen the same flourish in the design of municipal buildings.

No expense was spared in facing buildings in Portland stone, or in laying vast floors of marble, or even in part-lining walls, or carving banisters and columns in marble. What a contrast with the earthy redness of so much Victorian architecture! The generous use of bronze or other gilt ornamentation further emphasised the change. An immediate stylistic characteristic was the repeated use of the arched colonnade or the incorporation of rich Classical, or more elaborately Baroque, columns. Domes, also, came into vogue and countless architects

tried their hand with varying results. John Betjeman dismisses the dome over Harrods (1901) as 'awkward' and 'disastrous', finding more merit in the 'jaunty' dome of the Old Bailey (1902), which suffers mainly 36 from its proximity to Wren's St Paul's Cathedral.

The Ritz, and all it represents, is Edwardian architecture at its most delicious. This hotel, built in Piccadilly in 1904, and still proudly isolated by its neighbouring on Green Park, was the design of a young Paris/London firm run by Arthur J. Davis and Charles Mewès. This was the first steel structure in London, though the designers in no way emphasise this. On the contrary, the entire frame is clothed in Portland stone. From the elegant colonnaded façade (a sign indicating the 'Rivoli' bar makes the French reference unmistakable), one is swept up into the entrance halls and past marble columns into the tea

36 *The 'jaunty' dome of the Old Bailey (1902), much admired by John Betjeman.*

37 *Edwardian Colonial living, South Africa, 1904.*

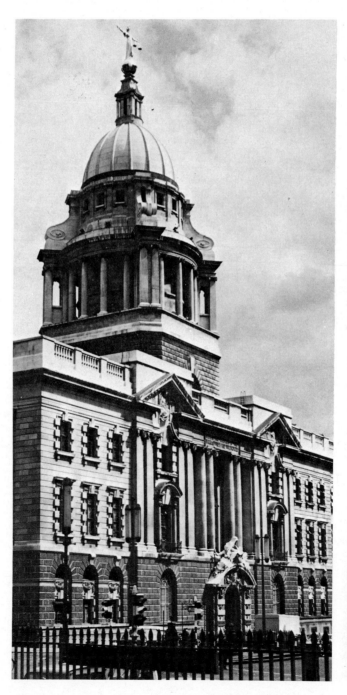

room, decorated in a glittering interpretation of the Classical French Louis XVI style; sparkle is added by a generous use of mirroring, by the richly gilt fountain and by the lofty gilt trelliswork frieze; a 'Palm Court' par excellence.

Mewès and Davis were also responsible for the equally Edwardian, though less feminine, Royal Automobile Club building of 1908–11. The swimming bath could almost be a film setting for an epic of Ancient Rome, so strong is the Classical feeling here – with such carefully chosen references to the 'Antique' as the bronze torchères.

These are but two good examples from a list that is endless, for few cities in England are without their monuments to Edwardian architecture. In London, the Victoria Memorial (1901) by Sir Thomas Brock is a further product of the style with its marble mermaids and gilt-bronze figure of Victory. A tour might include the Marylebone Town Hall by Sir Edwin Cooper (how readily the silk-hatters were awarded knighthoods!) or the Chelsea Town Hall in the King's Road.

On a more humble scale, Edwardian architects turned their talents to a few highly attractive 'garden cities'. Port Sunlight (1905), Bournville (1908), Letchworth Garden City (1903) and Hampstead Garden Suburb proved as successful as they were idealistic, and were a positive contribution to twentieth-century domestic architecture.

If the following statement sounds idealistic to the point of *naïveté*, then the man who wrote it should be forgiven for, in fact, his was perhaps the single most important contribution to the design of moderate houses for the middle classes. For M. H.

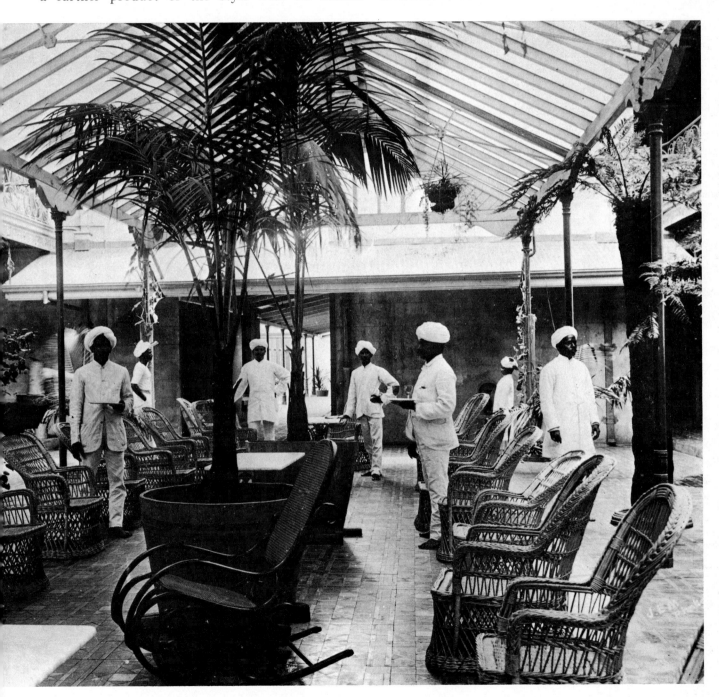

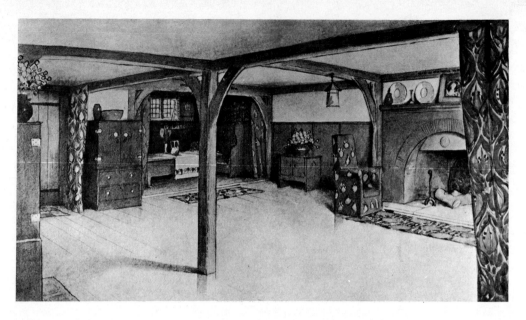

38 *Baillie Scott design for a domestic interior, 1906. Emma Reeve Collection.*

39 *The living room at 78 Derngate, Northampton. Designed by Charles Rennie Mackintosh for W. J. Bassett-Lowke, 1916.*

40 *Evans House, Chicago. Designed by Frank Lloyd Wright, 1908.*

38,42 Baillie Scott declared rather grandly that 'the building and adornment of the house is surely the most important as well as the most human expression of the Art of man.' Baillie Scott's success mushroomed after the publication of his first scheme by *The Studio* in 1895, and he received many commissions from abroad as well as in all parts of England. By 1906 he was able to assemble an interesting collection of decorative schemes in his *Houses and Gardens*. The first impression is one of 'quaintness', though 'quaintness', as a term for a kind of suburban pre-fabricated picturesqueness, has become almost a term of disparagement. The folksiness of Baillie Scott's projects, combining strong, simple, rustic furniture of unpretentious construction with colourful, soft furnishings, often with stencilled decoration repeated in wall friezes, survives as a charming example of a true effort at simplicity. Baillie Scott was clearly aiming at the not so rich followers of William Morris with a feeling for the 'mock pauper/ artisan' style. His use of timber beams and hearth settles is a definite harking back to a rustic ideal. The rows of characterless 'half-timbered Tudor' suburban houses, that survive alongside 'Georgian' homes with coach lamps, are a sad tribute to the efforts of such men.

The work of Charles Rennie Mackintosh and Charles Annesley Voysey has been discussed in a separate context in the framework of the English Art Nouveau movement. There is one interior by Mackintosh, however, which bears inclusion here for it so admirably acts as a pointer from the style of the Edwardian period to the style of the Jazz Age. In 1916 the Glasgow architect was commissioned to totally redecorate the Northampton home of W. J. 39 Bassett-Lowke, a prosperous industrialist who is discussed in the section on Edwardian toys. The interior shows a marked development in Mackintosh's style, in his use of both line and of colour. For he has altogether abandoned the delicate interlaced patterns and drooping curves of the stencilled wall decorations

and stained glass work which he created, for, say, the Willow Tea Rooms in Glasgow. In their place we find aggressive patterns based on crisp, zig-zag and triangle or chequer motifs, whilst instead of the former fondness for delicate tones of silver, lilac or mauve breaking expanses of white, we find a predilection for black, covering entire walls, and the black walls and furniture are relieved with a strong mustard colour or touches of red. Mackintosh, indeed, managed to keep out of step with his generation by striding constantly and resolutely one pace ahead.

One could say the same of the American architect, Frank Lloyd Wright. Paul Simon of Simon and Garfunkel said very simply:

Architects may come and,
Architects may go and,
Never change your point of view,

... [but] ... I'll remember Frank Lloyd Wright. Wright was the pupil of Louis Sullivan, himself one of America's most important architects, whose Schlesinger and Mayer store in Chicago (built 1899–1904) was one of the earliest successful experiments in giving liveliness to a 'skyscraper' building. During the early years of this century, Wright's pre-occupation was with domestic archi- 40 tecture, and his medium was the private 'prairie' house. These buildings have an organic quality, their integration with the countryside being achieved by a judicious blending of local materials. Wright exploited volume in a new and daring way, with easy divisions between inside and outside space, with a bold 'open-plan' approach, and by frequently doing away with ceilings to expose the inner space of roofs. Skylights in these roofs would give a constantly shifting pattern of light and shade. The extended playful roofs, which Wright favoured, and his spatial freedom are somewhat Japanese in character. They are also indisputably 'modern' and, indeed, by 1904 Wright was designing houses that have not been conceptually overtaken to this day.

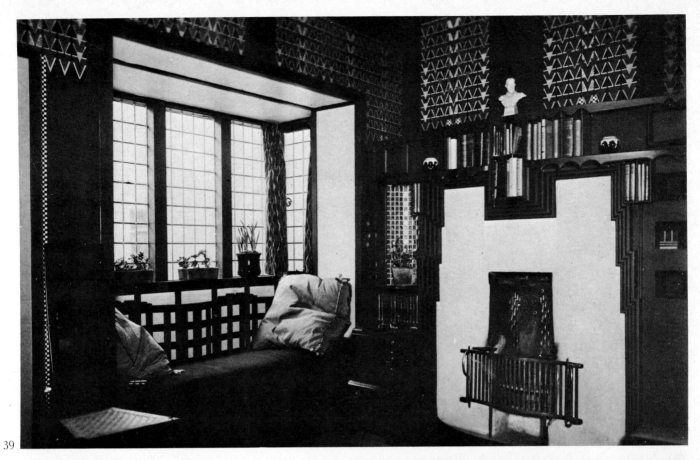

39

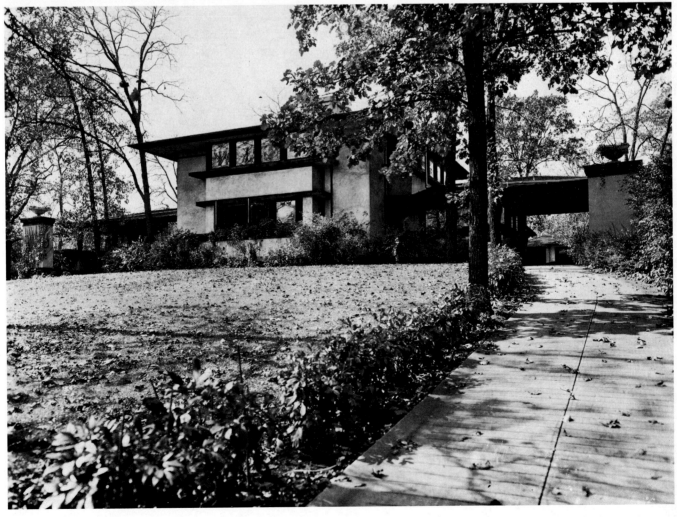

40

FURNITURE

THE EDWARDIAN age was not, by any means, a great age of cabinet-making. Very little top quality furniture was produced in England during this period. Perhaps if the cabinet-makers themselves had been enjoying a true feeling of creativity, their enthusiasm might have been reflected in their work. The sad truth was that a general lack of inspiration led to a rather mechanical quality in the majority of the furniture produced. The following quotation, 41 taken from the catalogue of a large firm of Edwardian cabinet-makers is all too symptomatic of the prevalent attitude: 'Modern furniture designs consist very largely in the imitation of old styles. Usually we content ourselves with adapting and elaborating old designs [which action purists might justly describe as sacrilege!], but to satisfy those who care to have exact copies, we have ventured to reproduce more exactly some of the best examples.' So it is that so much Edwardian furniture derives from seventeenth- or eighteenth-century prototypes.

DINING ROOM FURNITURE

of Great Variety in Design

A HANDSOME WALNUT SIDEBOARD
OF EARLY XVIIIth CENTURY DESIGN
ON VIEW IN THE SHOWROOMS

CARRIAGE PAID CATALOGUES FREE

MAPLE & CO

41 *An advertisement of 1914 for reproduction furniture popular at the time.*

42 *The 'Manx Piano' designed by M. H. Baillie Scott, 1887–1900. Sotheby's Belgravia, London.*

43 *Paris Exhibition wardrobe, 1900, by Ambrose Heal.*
Oak inlaid in ebony and pewter.
Heal & Son Ltd, London.

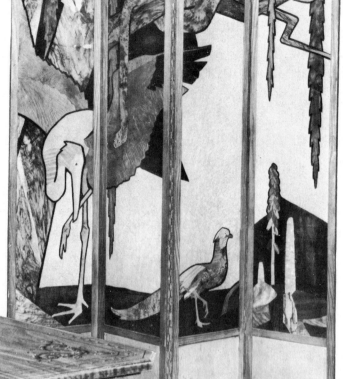

44 *Marquetry screen designed by Sir Frank Brangwyn for the Rowley Galleries, Kensington. Museum and Art Gallery, Brighton.*

45 *Satinwood sidetable with painted decoration, about 1910. June Penn Collection, Hove.*

46 *Mahogany display cabinet attributed to Pratts of Bradford. Pewter, mother-of-pearl and fruitwood inlays, about 1900. Sotheby's Belgravia, London.*

45

44

The sad irony of this situation is that whilst the 'cabinet-making' profession was, through lack of inspiration, producing furniture of fairly mediocre quality, the creative furniture designers, from whom one might have hoped for a combination of inventiveness and fine quality, were largely working in a simple, almost rustic, style and the results were correspondingly primitive from the point of view of craftsmanship.

No disrespect is intended for this last group, for it embraces several highly important designers and a great deal of interesting furniture.

This 'modern' group must include C. R. Mackintosh, and Charles Annesley Voysey, Baillie Scott, Ernest Gimson, various designers producing English 'Art Nouveau' furniture retailed by such firms as Liberty & Co., or the more functional furniture sold by Heal's, and, in America, Frank Lloyd Wright and Gustav Stickley, among others.

The best known of the former group, whom we shall call the 'Revivalists', are perhaps the London firm of Edwards and Roberts, and Pratts of Bradford, from whose catalogues a very full picture can be drawn. Satinwood was popular with the 'Revivalists' 45

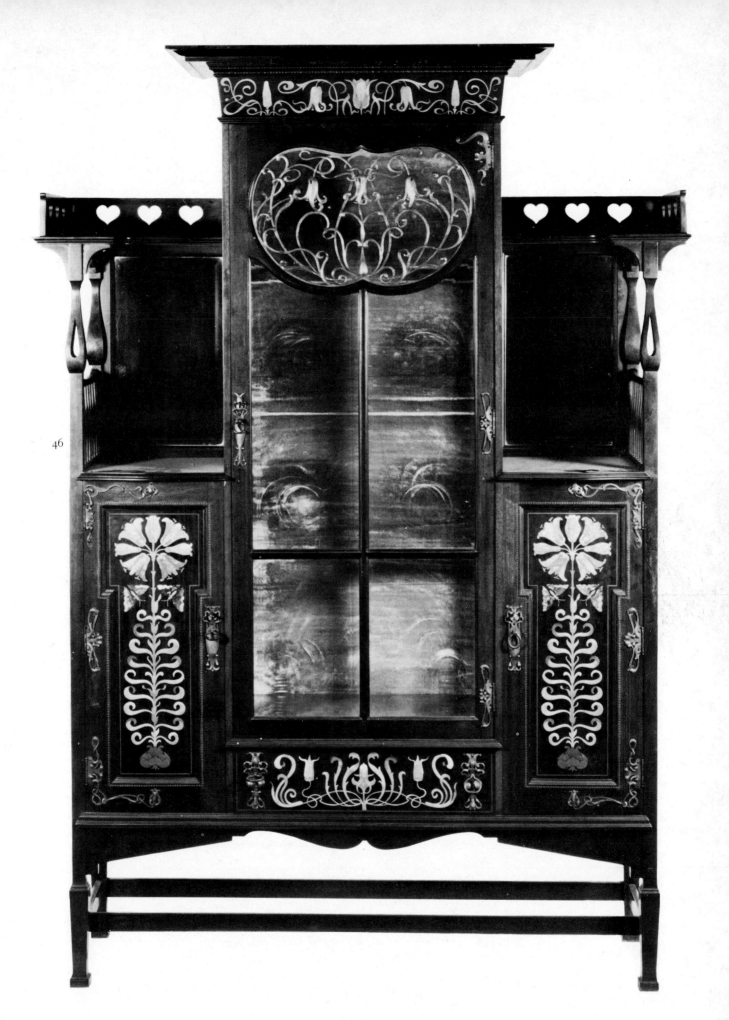

46

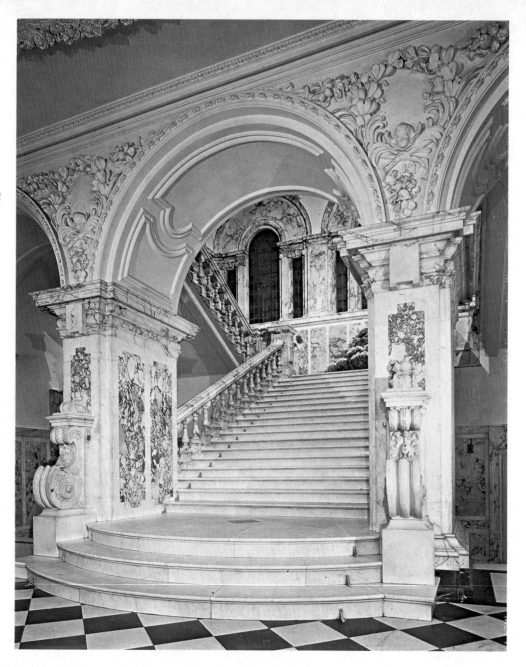

and became very distinctive of the Edwardian period. Equally distinctive was the tendency to thinness in the limbs and structure of furniture. This marks a change from the heavy opulence, the 'inflated' quality, of high Victorian furniture. Pratts of Bradford were not alone in favouring the use of native British timber, and so popular woods included oak, walnut, ash, stained pine, hazel and birch. As for decoration, these 'Revivalists' would frequently incorporate discreet and typically 'thin' floral wood-marquetry scrollwork, or would enhance pieces with light, wispy painted floral motifs. In France at this time, the craft of marquetry was enjoying a revival as a result of the work of Emile Gallé and Louis Majorelle at Nancy. They employed exotic or local fruitwoods in elaborate figurative decorations to an extent that was seldom seen in England. The closest rival to these Nancéens was possibly the Rowley Galleries of Kensington, whose premises in Kensing-

ton Church Street still bear their old trade sign. The illustrated screen, with its lush jungle scenes, was designed by Frank Brangwyn, and is a rich example of their work.

The prevalent taste for 'Revivalist' furniture is well evoked through the medium of contemporary advertising or painting. If, for instance, an Edwardian corset manufacturer were advertising his wares with an image of a young woman suitably constricted, it is highly likely that he would provide her the support of an 'Edwardian Hepplewhite' shieldback chair. Similarly, an Edwardian genre painter depicting a scene of domestic anguish would most likely pose his characters with equally 'modern' furniture. Further typical pieces are the envelope-flap-top side tables that are almost a phenomenon of the Edwardian years. The table illustrated is typical; in satinwood 45 heightened with painted motifs, its slatted side panels could date only from this period. Many tall, slender

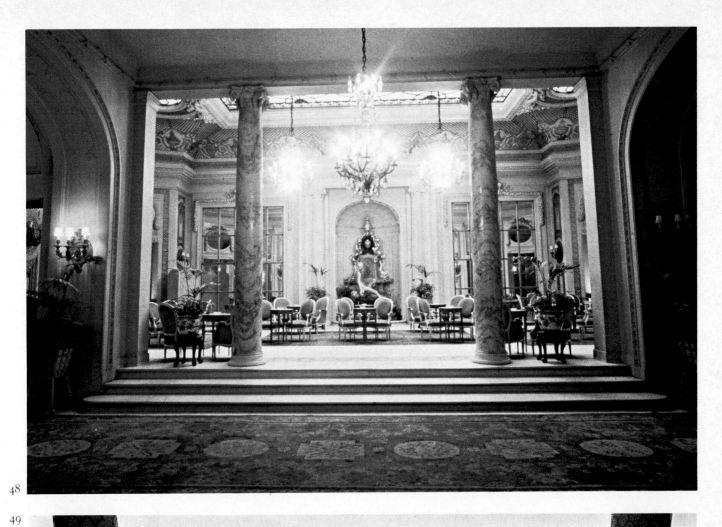

48

49

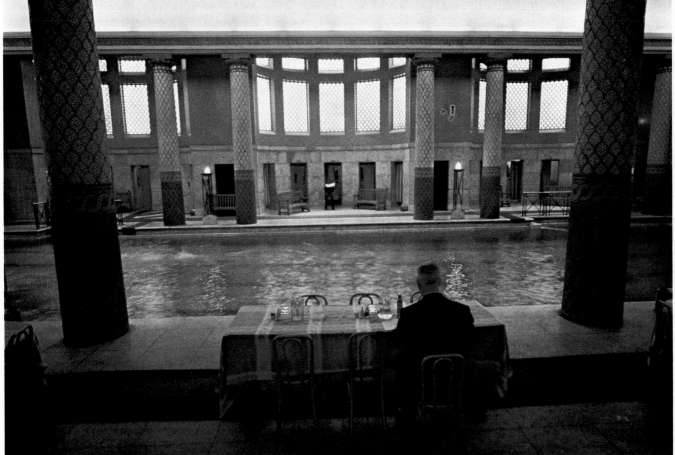

51

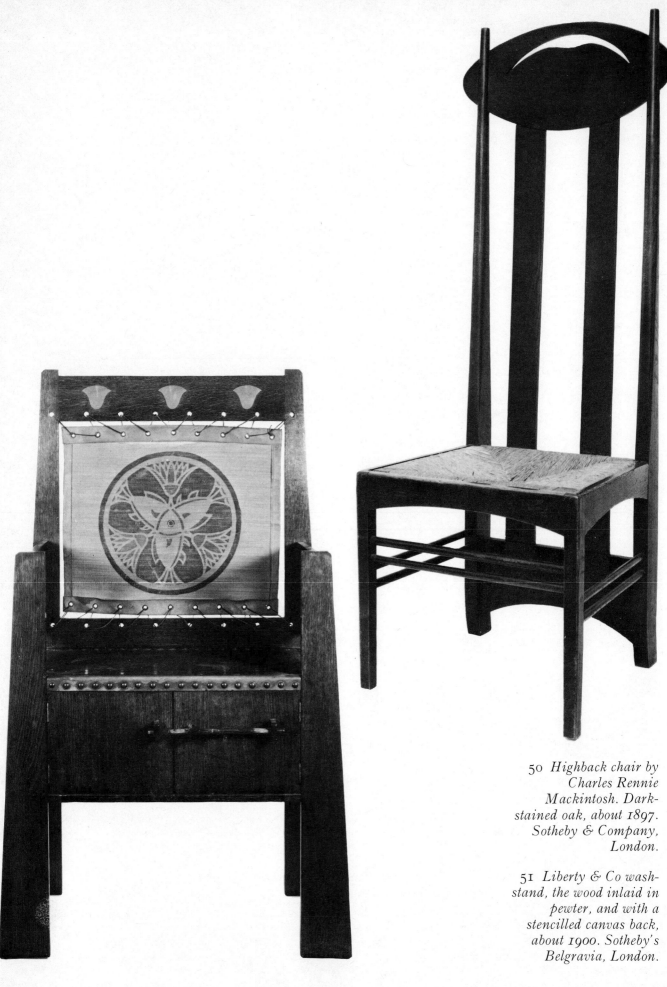

50 *Highback chair by*
Charles Rennie
Mackintosh. Dark-
stained oak, about 1897.
Sotheby & Company,
London.

51 *Liberty & Co wash-*
stand, the wood inlaid in
pewter, and with a
stencilled canvas back,
about 1900. Sotheby's
Belgravia, London.

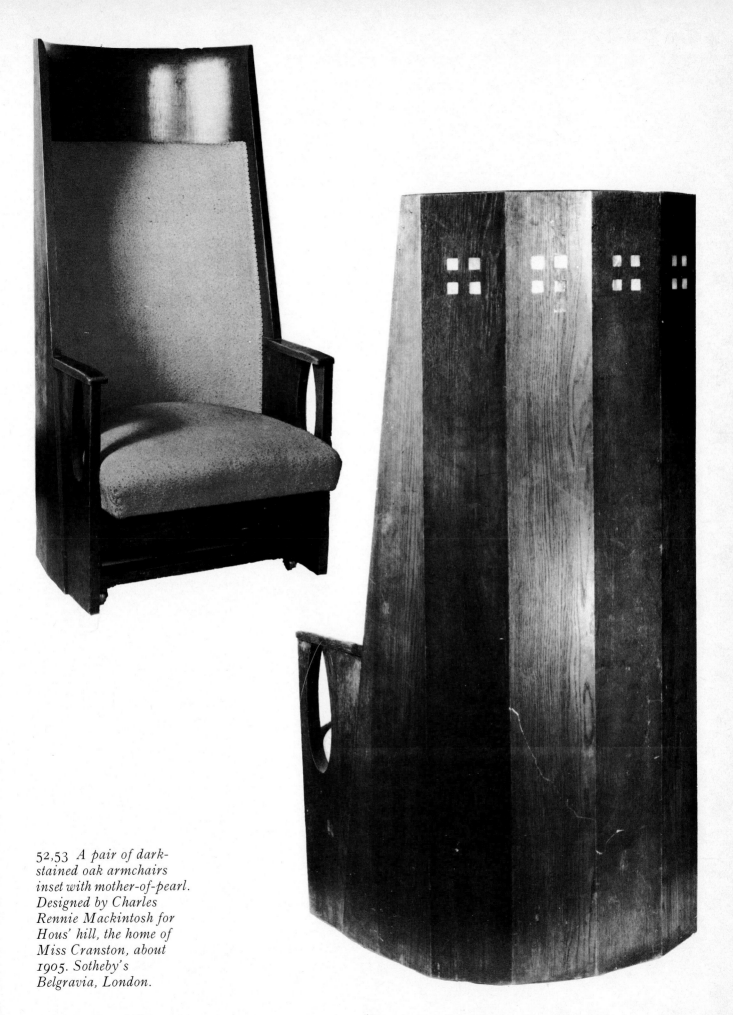

52,53 *A pair of dark-*
stained oak armchairs
inset with mother-of-pearl.
Designed by Charles
Rennie Mackintosh for
Hous' hill, the home of
Miss Cranston, about
1905. Sotheby's
Belgravia, London.

slope-fronted bibliothèque-secrétaires were designed in a revival of the 'Georgian' style, the fall-fronts generally inlaid with a few trailing scrolls.

In London the firm of Edwards and Roberts were great producers of Edwardian satinwood from their workshops in Soho. We should be grateful to them for their practice of stamping their furniture. Our gratitude should extend to the Bradford firm, 46 Christopher Pratt & Sons, for their furniture too was always marked, either with a metal plaque or paper label.

Christopher Pratt was first apprenticed as a cabinet-maker in 1830. He was soon to form a company of his own which flourished throughout the Victorian period, prospering on the profits of thriving Bradford industry. By 1900, the firm was able to show a trading profit of £44,600, and could boast fourteen individual departments providing virtually every type of furnishing in addition to an advisory service on interior decoration. It was in 1901 that they started the issue of trade catalogues which act as a guide to the tastes of the Bradford *bourgeoisie*. The balance is heavily in favour of reproduction or derivative pieces. We find 'Sheraton' sideboards, 'Queen Anne' tallboys, 'Jacobean' dining suites, 'Chippendale' or 'Hepplewhite' chairs or examples of the 'Elizabethan' style. Pratts did not cater exclusively for this provincial conservatism, however. Their catalogue also offered 'Art Nouveau' cabinets, not very inspired in their form but with attractive wood or metal inlays. Their efforts to capture this younger market explains the 'Voisey' (sic) card table with pewter inlay and austere structure that also appears in their catalogue. Liberty & Co. chose Pratts as their Bradford agents, but the London store's efforts to bring their advanced designs to Yorkshire did not prove a financial success. Richardsons of Hull, Marsh, Jones and Cribb of Leeds, and Gillows of Lancaster are three firms that can be compared in their output with Pratts.

For those looking for furniture more adventurous in concept than that produced by the 'Revivalists', there was a quite considerable output, especially between about 1900 and 1910, of furniture in a taste which blended features of Continental Art Nouveau with a more English style derived from the Arts and Crafts movement. There survive many glazed cabinets of tall proportions with leaded panes incorporating coloured glass rose balls, tulips or hearts. It is not uncommon to find marquetry 44 decorations of attenuated flowers and, on occasion, the flowers were inset in mother-of-pearl. Varieties of chairs, desks and sideboards were created in the style and often were enhanced with simple fretted motifs. Liberty & Co. became clearly associated with this style. Their furniture would sometimes incorporate panels of copper or pewter, *repoussé* with Art 51 Nouveau tendrils. Many massive and crudely made dining or bedroom suites were manufactured in a debased version of the Liberty style.

54

54 *Design for the living room for the House of
an Art Lover by Charles Rennie Mackintosh, 1901.
Mackintosh Collection, University of Glasgow.*

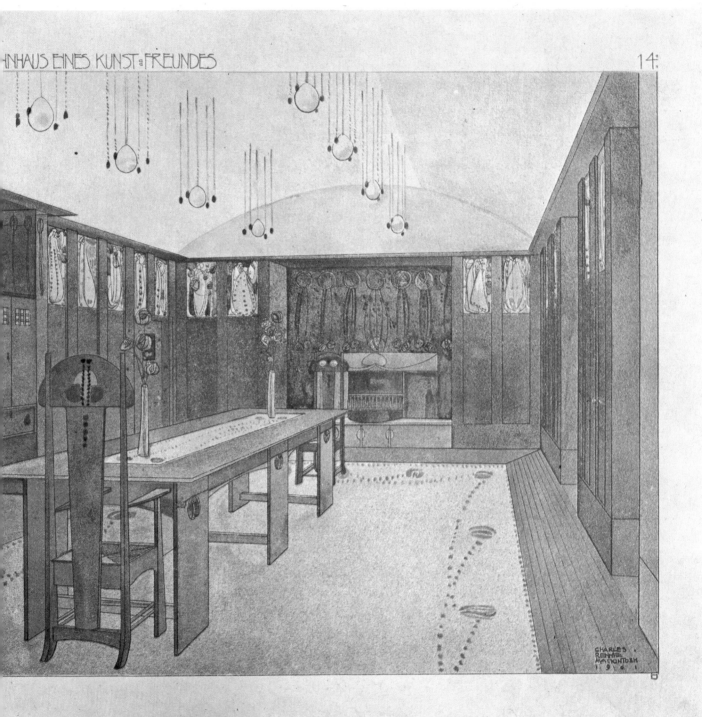

55

The most sophisticated British Art Nouveau furniture was surely that created by Charles Rennie Mackintosh. Although the execution of his designs was fairly crude, the refinement of his proportions is without parallel. Most notable perhaps were his experiments with the chair, not so much as a creation 50,59 to sit on, more as a personal credo. The spartan beauty of his lofty, ebonised oak ladderback chairs rivals his more precious white-painted highbacks.

Mackintosh could apply minimal decoration with maximum effect. The simple chequer insets of 52,53 mother-of-pearl on the extended barrel-back arm-chairs created for Miss Cranston are characteristically discreet, yet refined, touches. Most notable was the happy synthesis that Mackintosh could achieve in integrating his furniture within his architectural schemes, and the same praise might be sung of 23,38 Voysey and Baillie Scott. All three were outstanding

55

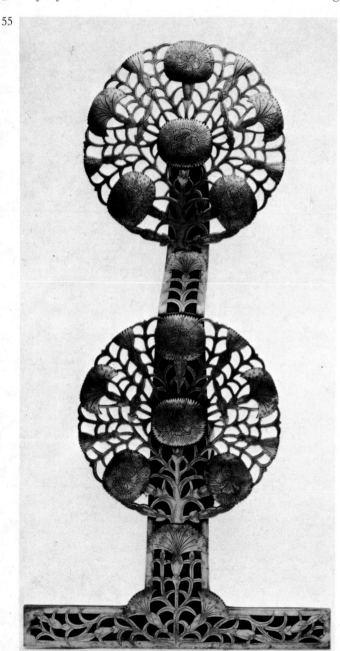

for the completeness of their rôle as architects of total environment.

Ernest Gimson was a furniture designer who had started his career as a student of architecture in Leicester. In 1890 he became one of the younger founder members of Kenton and Co., a London- 56 based firm whose avowed intention was ' . . . to make the best possible furniture of its time, with the best materials and the best workmanship attainable . . . ' The members all had architectural training, and theirs was the first attempt after Morris and Co. and the Century Guild to put Arts and Crafts principles into practice in the creation of furniture. After a short initial burst of success, lack of capital soon led to the dissolution of the group. Gimson then moved to Gloucestershire, where he founded the Daneway 55 works at Sapperton in 1902. Although Nikolaus Pevsner describes Gimson as 'the greatest of the English artist/craftsmen', this is not strictly true, since he was primarily a designer. His involvement was such, however, that he would always supervise the craftsmen executing his designs, and would advise or modify as the work progressed. As a result his furniture has both quality and honesty, in the most unpretentious way. Gimson designed presti-gious pieces inlaid in mother-of-pearl, ivory or bone and silver-mounted; he was probably happier, though, with simpler pieces in native oak, elm or yew.

In America, a similar dichotomy existed to that which we have seen in England between the 'Revival-ists' and the 'Modern' schools. 'Eclecticism' would be a more apt term, perhaps, than 'Revivalism' to describe the experiments of the Americans, for they had little culture of their own to draw upon and yet, through an eagerness to give an identity to American craft, were loath to plagiarise European styles. The furniture made, for example, by the Tiffany Glass 58 and Decorating Company borrows rather from the Near East or from ancient Greek, Roman or Byzan-tine models. The chairs and table illustrated are typical. The marquetry work of the chairs is remi-niscent of mosaic patterns, whilst the bronze and oak table is reminiscent of Greek or Roman stands. European Art Nouveau had virtually no influence on American furniture design. Charles Rohlfs' elaborate chair of about 1898 is an extraordinary exception.

It is certainly significant that in America, as in England, or indeed elsewhere in Europe, the most modern, the most progressive furniture was fre-quently the work of architects. Frank Lloyd Wright 40 brought his genius to the design of furniture which can and should be considered on a higher plane than the merely utilitarian. For these are formal experi-ments, interplays of horizontal and vertical, of solid and void, that deserve to be termed architectural sculpture. From all accounts, Wright in America succeeded in a similar way to Mackintosh in Scotland, in conceiving furniture that for all its grace was actually damned uncomfortable to use, but it seems irrelevant to level this as a criticism. George Washing-

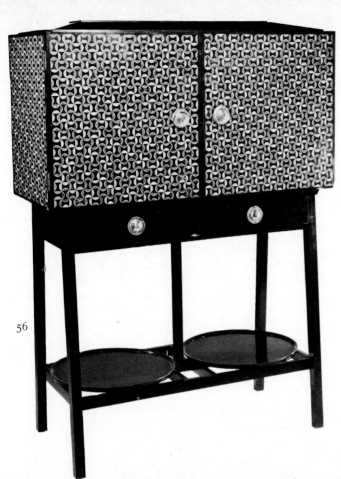

ton Maher was another Prairie School architect to create clean-limbed, sometimes austere, modern furniture, similar in concept to that of Wright, with whom Maher had trained.

Architect-designed furniture could indulge in extremes, since it was most frequently made for specific private commissions. Wright's vigorous, simple style was made popular with a wide public through catalogues such as that issued by the company of Gustav Stickley, founded in 1898. The emphasis was on oak, upholstered in hide or canvas, mounted in copper or brass. The aims were simplicity, durability and comfort, and the forms were plain, severe, and structural. The enormous popularity of this style of furniture encouraged bevies of imitators, and though Stickley did his best to emphasise his trademarks, the rivalry of other competitive furniture-makers sadly drove him to bankruptcy by 1916.

55 *One of a pair of polished steel fire dogs by Ernest Gimson. Made by Alfred Bucknell in the Daneway workshops, about 1910. Sotheby's Belgravia, London.*

56 *Marquetry cabinet and stand designed by Ernest Gimson for Kenton and Co. Ebony, orange, holly and palm woods, the silver handles hallmarked, London 1891. Christie Manson and Woods Limited, London.*

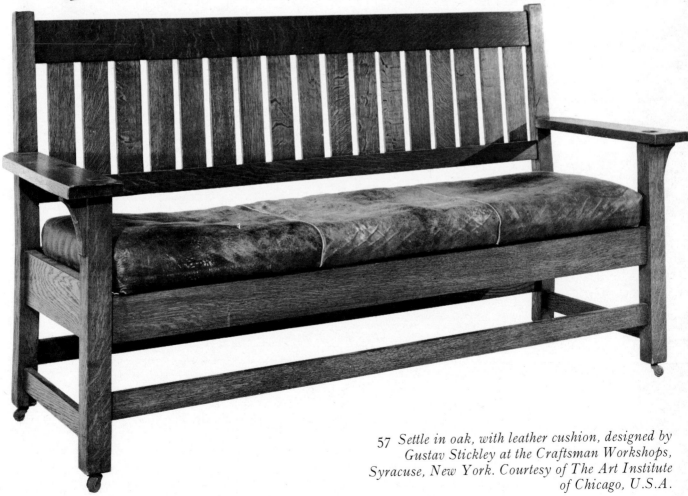

57 *Settle in oak, with leather cushion, designed by Gustav Stickley at the Craftsman Workshops, Syracuse, New York. Courtesy of The Art Institute of Chicago, U.S.A.*

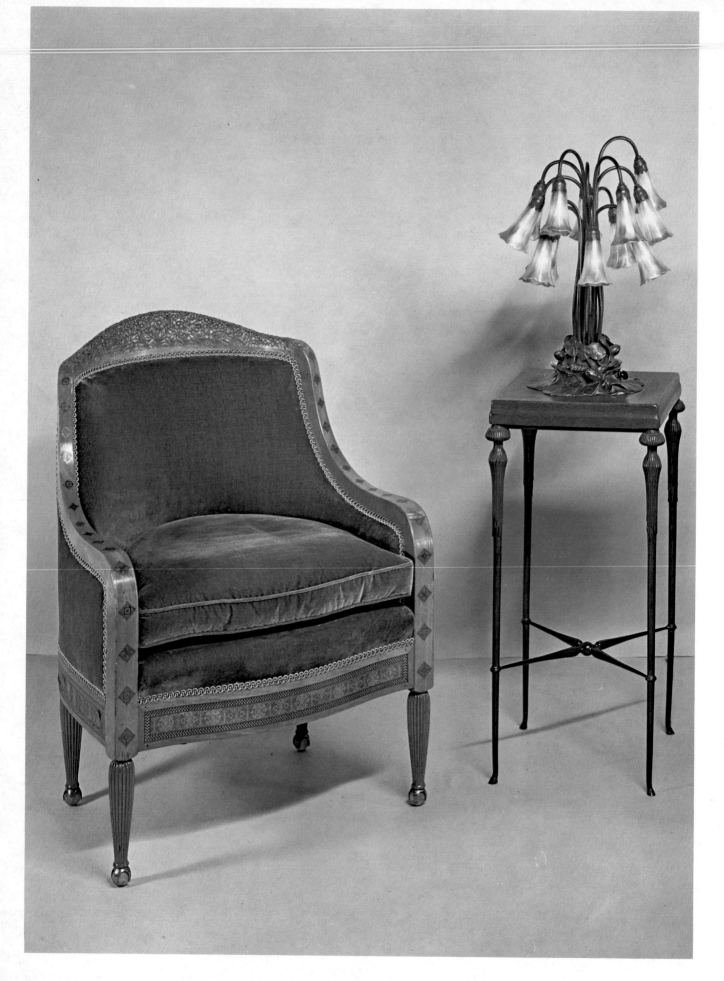

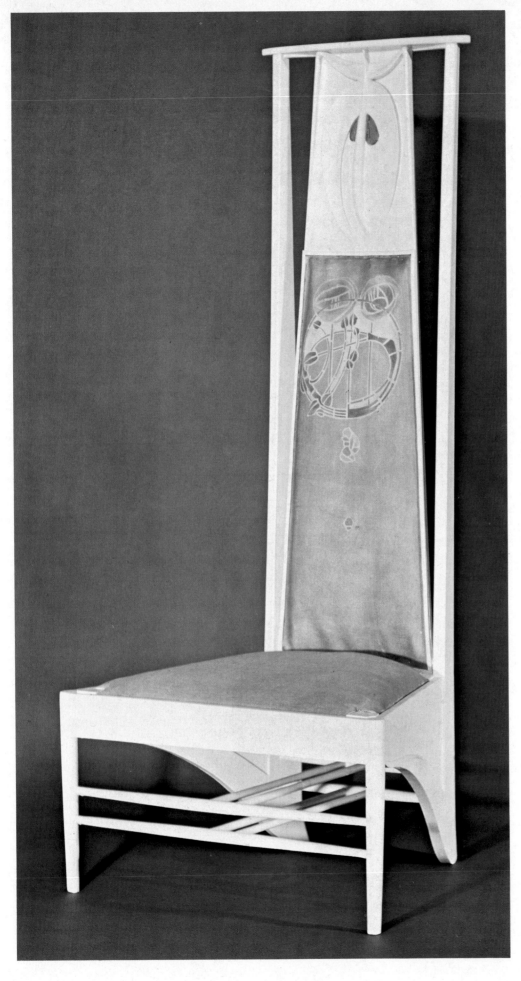

58 *Furniture and lamp made by Tiffany Glass and Decorating Company and Tiffany Studios, 1890–1905. Armchair: The Metropolitan Museum of Art. Gift of Mr and Mrs Georges E. Seligman, 1964. Table: The Metropolitan Museum of Art, Rogers Fund, 1966. Lamp: Mr and Mrs William G. Osofsky.*

59 *Chair with stencilled canvas back by Charles Rennie Mackintosh, about 1901–2.*

SCULPTURE

61 'THE SPIRIT of Ecstasy', arguably the best known British sculpture, was created by Charles Sykes in 1911 to adorn the bonnets of Rolls Royce motor cars. This sculptor, who studied under Walter Crane, had been introduced to the world of the motorcar in 1903 when he had been given a commission for a bronze by Lord Montagu of Beaulieu. Charles Sykes' mascot, together with the imposing 'Parthenon' radiator, have established themselves as ultimate symbols of Englishness. They can also be described as embodying some of the most distinctive features of Edwardian sculpture. Their rather pompous Englishness is, in itself, most Edwardian, though more specific characteristics can be observed in addition. For here combined are the two main streams of Edwardian decorative art. In the radiator we find the grandeur and the splendour of Mewès and Davis's Classicism as expressed in their Louis XVI, renaissant Classical 48 Ritz. This radiator was created for the 'silk-hatted brigade', the readers of the *Architectural Review* who were encountered in the references to architecture and interiors.

The mascot itself, however, is very French in character, very 'Art Nouveau'; its veiled, symbolist character and organic and free-sculptured interpretation remind one of the notorious American dancer, Loïe Fuller, with her yards of swirling silks, as modelled in bronze by Raoul Larche or Pierre Roche. This is the sculpture of the more open-minded, anti-establishment movement, prepared to accept a strong influence from abroad.

Having perhaps implied that Edwardian sculpture can be divided into these two clear categories, it must now be stressed that, in fact, the various distinctions are by no means so clear cut. During the Edwardian period, English sculpture was undergoing a transition from what had been christened the 'New Sculpture' by Edmund Gosse in the *Art Journal* of 1894, to what is generally accepted as 'Modern British' sculpture. The 'New Sculpture' of the 1880s and 1890s is a school tending towards a softness of style, an Impressionistic quality that is unquestionably French in origin. And in the sense that Edwardian sculpture is a development of this 'New Sculpture', a French stylistic background must be acknowledged to the majority of turn-of-the-century English sculpture, however 'English' the subject-matter. Thus divisions can be made on two levels: on the stylistic level and in the choice of subject.

When approaching Edwardian sculpture from the stylistic angle it becomes a question of assessing the extent of French influence. Rodin is an acknowledged giant of sculpture in the last quarter of the nineteenth century, and it is understandable that many artists should have felt eager to work in his highly emotive, Impressionistic style. Rodin's Expres- 65 sionist work has a plastic immediacy. Its unfinished, un-slick quality stresses aggressively the efforts and emotions of the sculptor. An observer is made immediately conscious of the artist's involvement with his clay by his confrontation with the chunky thumbed bronze in contrast to the impersonal quality of a classically smooth and too-perfect bronze from which any signs of the creative process have been very carefully erased. Rodin was the most important, though by no means the only, Continental exponent of this style. One finds a similar 'Impressionistic' feeling in the work of Aimé-Jules Dalou, a Paris-born artist who had a certain influence as a teacher in South Kensington and Lambeth before returning to Paris in 1880; or in the naturalistic, social realist work of Constantin Meunier.

The foremost English sculptor was Charles Ricketts. His first meeting with Rodin was at a dinner party in 1903, after which he commented conceitedly in his diary that Rodin was 'hardly conscious that I was a rather more than ordinary man who probably knows and understands his work better than any man in Europe.' Ricketts started his sculptural work in 1905 and found so little appreciation that he abandoned it about 1910. At his first exhibition in 1906 he managed to sell only one bronze 'and that', he rather ruefully confesses, 'to a friend!' Ricketts

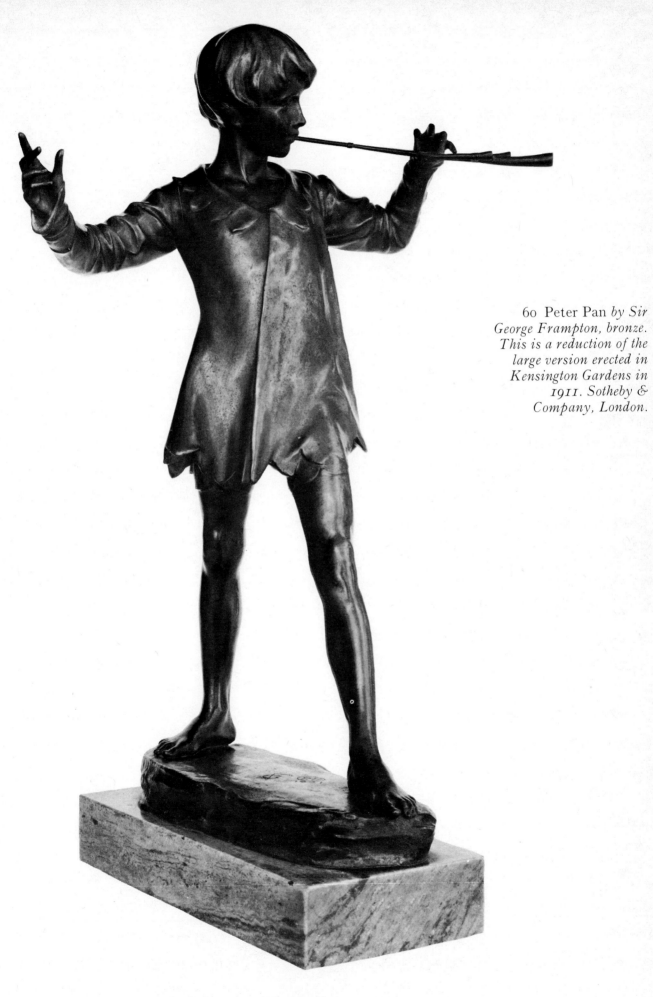

60 Peter Pan *by Sir George Frampton, bronze. This is a reduction of the large version erected in Kensington Gardens in 1911. Sotheby & Company, London.*

61 The Spirit of Ecstasy *created by Charles Sykes in 1911 to adorn the* *bonnets of Rolls Royce motor cars and still used on this 1973 model.*

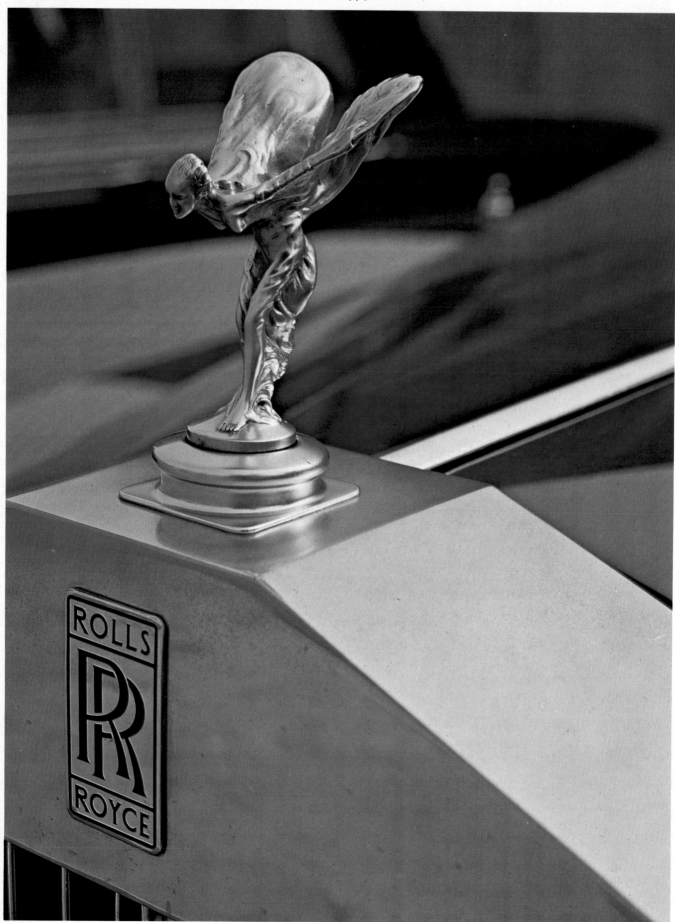

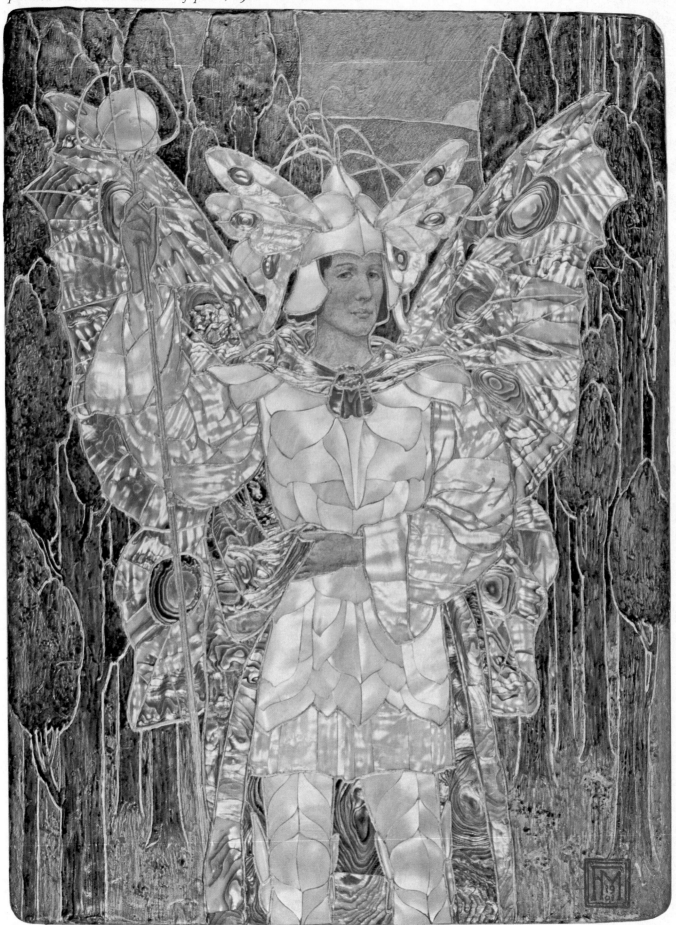

63

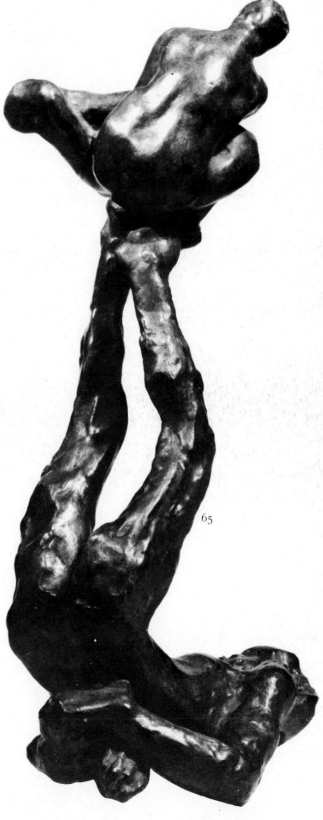

63 The Rock Drill
by Sir Jacob Epstein, bronze, 1913–4.
The Tate Gallery, London.

64 Anton Wolmark
by Henri Gaudier-Brzeska, bronze, 1913.
Fine Art Society Ltd.

65 The Juggler
by Rodin, bronze, about 1892–5.
Roland, Browse and Delbanco, London.

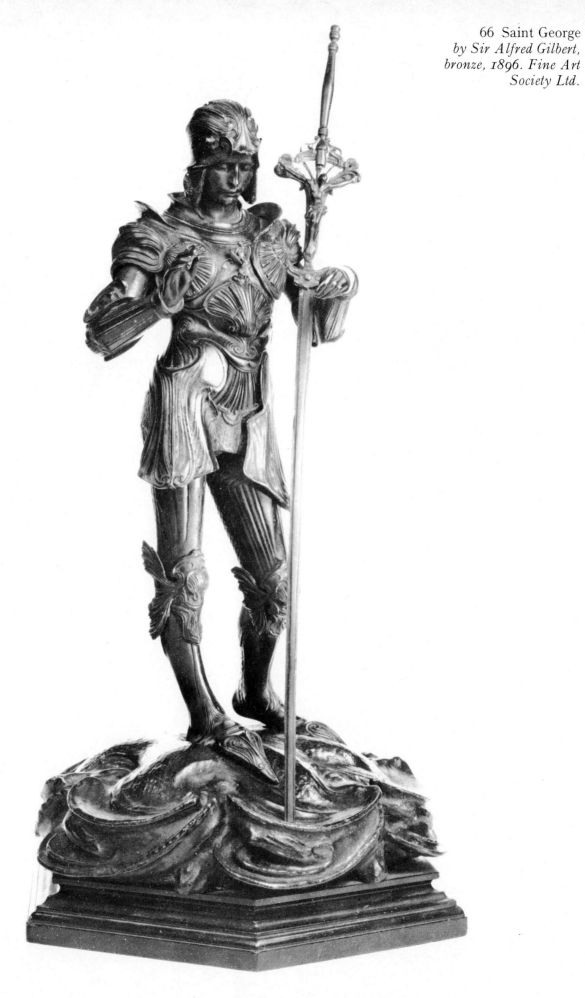

66 Saint George
*by Sir Alfred Gilbert,
bronze, 1896. Fine Art
Society Ltd.*

made the mistake of working in an unadulterated version of the style which was clearly too highly charged on the emotive plane to be appealing to English tastes. It is significant though that, despite the isolation Ricketts imposed on himself by the uncompromising aspect of his work, we are now able to see, with the benefit of hindsight, that it was under the direct shadow of Rodin that those artists developed who were to create a 'Modern' British School of sculpture. It is no surprise to learn that Ricketts was amongst the first to support another 63 important innovator, Jacob Epstein, when he arrived 64 in London in 1905; nor to hear that Henri Gaudier-Brzeska, who, like Epstein, became a member of the Vorticist movement, condemned all sculptors but 'Dalou, Carpeaux, Rodin, Bourdelle and a few others'.

Those sculptors had greater success who adapted the softness, the melting, plastic qualities of French sculpture to works in which the shift was towards the decorative or symbolist rather than the powerfully emotive, that is to say, who tempered the French style with an English restraint. An important and representative name in this context is that of Sir 66 Alfred Gilbert, who had set a precedent with such fluid sculpture as his effetely sensuous 'Perseus arming' of 1882, or his 'Icarus' of 1884. His own 67 'Comedy and Tragedy' of 1892 continued the trend which was taken up by many sculptors during the 1890s. Many visitors must have passed the 'Shaftesbury Memorial Fountain', or as it is better known, 68 the 'Eros' fountain, at Piccadilly Circus without realising that Sir Alfred Gilbert had created this monument in 1893 in a decorative interpretation of the French style. Gilbert's Memorial to H. M. Queen Alexandra at Marlborough Gate in London was finished in 1922 and is one of the purest English monuments created in Art Nouveau taste, though its date destroys its art-historical significance.

Another example can be found in Sir William Goscombe John, a Royal Academy sculptor who studied under Rodin in the early 1890s, yet who maintained a distinctive 'Englishness'. His 'Elf', for instance, of 1910 is very Edwardian in the innocent sensuousness of its subject, half-child, half-woman, and has a freshness and naturalism, a freedom from subservience to 'style' which show a creative interpretation of the freedom taught by the French School.

Leaving aside formal questions for the moment, a brief analysis of the choice of subject-matter in Edwardian sculpture reveals three basic categories. The first and smallest includes the highly emotive voluptuous figures of Ricketts, his erotic tumbling groups such as 'Paolo and Francesca' or 'Orpheus and Eurydice', in which the appeal is directed at the senses. A second category is that which works on set pieces drawn from a Renaissance Classicism or direct from Greek or Roman mythology. Certain of Gilbert's works, as we have seen, fall into this group. Frederick Pomeroy was another Royal Academy

67 Comedy and Tragedy *by Sir Alfred Gilbert, bronze, 1892. Fine Art Society Ltd.*

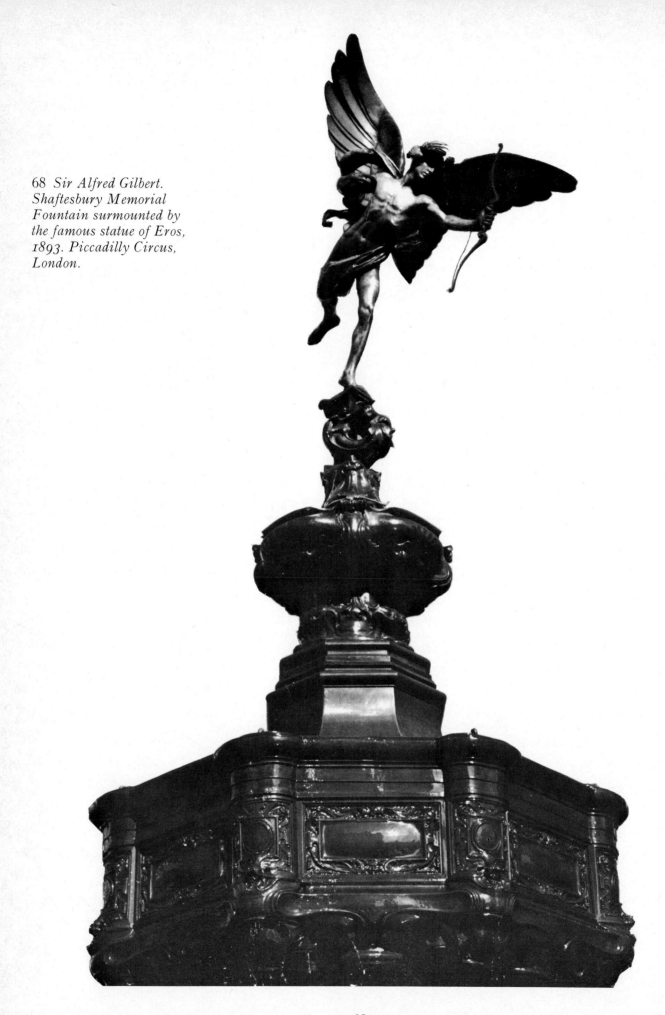

68 *Sir Alfred Gilbert.*
Shaftesbury Memorial
Fountain surmounted by
the famous statue of Eros,
1893. Piccadilly Circus,
London.

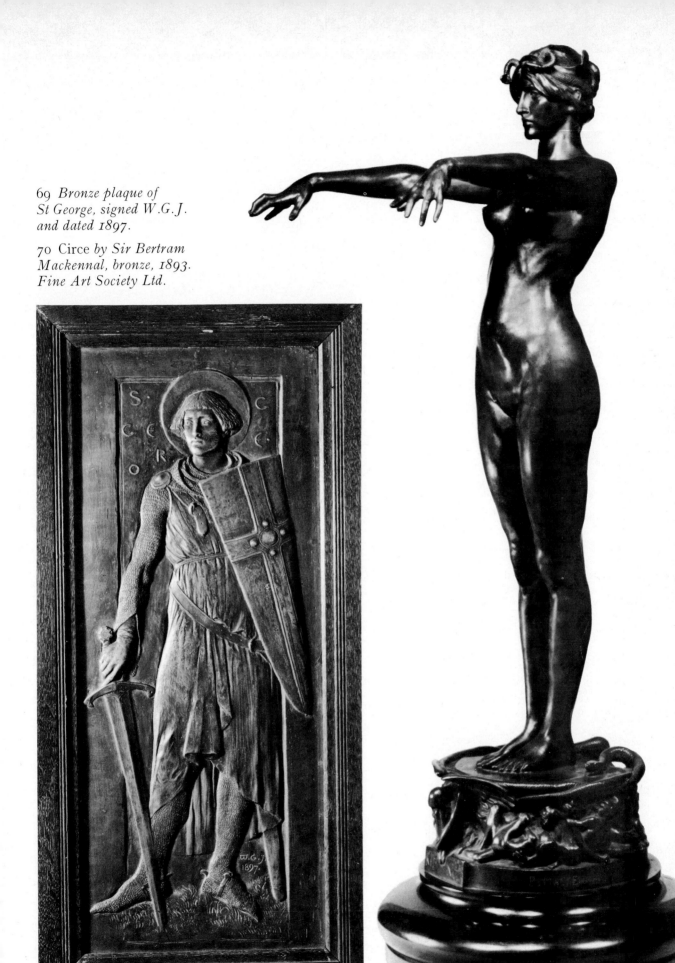

69 *Bronze plaque of
St George, signed W.G.J.
and dated 1897.*

70 Circe *by Sir Bertram
Mackennal, bronze, 1893.
Fine Art Society Ltd.*

69

70

71,72 Music *and* Dance.
*A pair of silver bas-reliefs by Sir George Frampton,
signed and dated 1894.*
Sotheby's Belgravia, London.

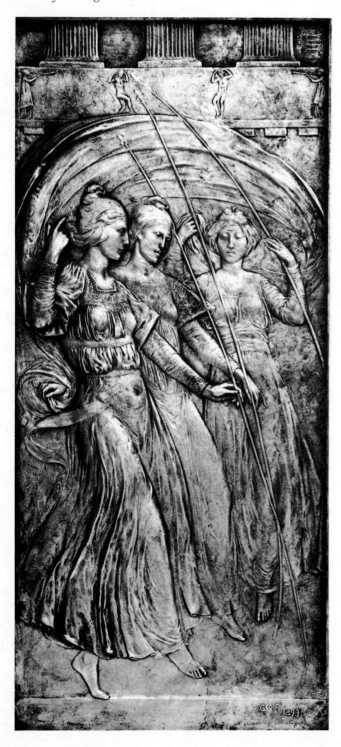

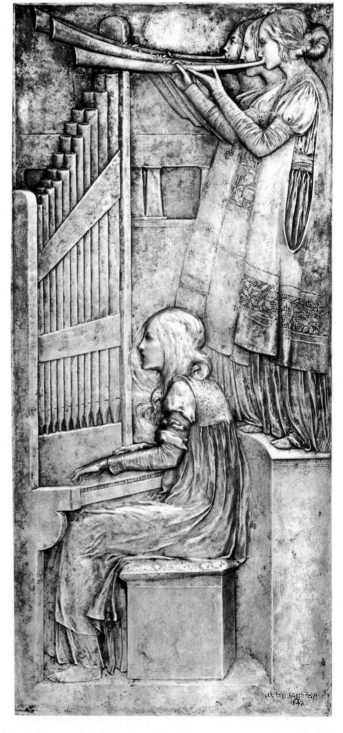

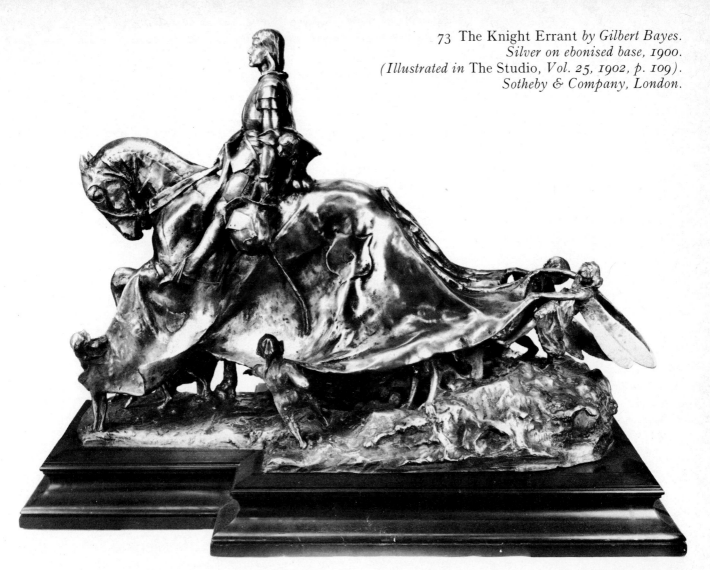

73 The Knight Errant *by Gilbert Bayes.*
Silver on ebonised base, 1900.
(Illustrated in The Studio, *Vol. 25, 1902, p. 109).*
Sotheby & Company, London.

sculptor to attempt the Perseus theme in 1898. Sir
70 Bertram Mackennal's *Circe* of 1893 is a further example. Although many artists choosing their subject-matter within this category produced works in a pleasing new style, one could criticise them for the limitations imposed by their retrospective tastes.

Equally retrospective, yet looking in a different direction, was the third group which one might label 'English Romantic'. This embraces all those works which draw a wistful or symbolic inspiration from Medievalism. Here one finds the nostalgia of the
89 Pre-Raphaelites expressed in three-dimensional form through a series of sculpted images in keeping with a high proportion of the practices, if not the theories, of the Arts and Crafts movement.

If the influence of the Arts and Crafts movement can be felt in the imagery, it can be further seen in the efforts of artists within this group to destroy the barriers between 'fine' and 'applied' arts. There was a strong feeling during the last part of the nineteenth century that any distinction made between artist and craftsman was purely arbitrary and to be avoided. For a sculptor, a means of blurring this barrier was to work in mixed media, combining his artistry over the clay model with his craftsman's skill in incorporating precious metalwork, enamels,

carved ivory or wood, or working in gesso or plaster relief. The master in this field was George Frampton 60,71, who worked in endless combinations of materials, 72 causing Roger Fry to lament, perhaps unfairly, that 'some sculptors make up for the absence of idea in their designs by playing tricks with their materials; putting crystal globes into the hands, or, worse still, the bronze bases, or covering their busts with opals.' Sir Alfred Gilbert was accused in 1903 of having 'bred mischief in the English Schools of Sculpture' with his 'teased ornamental work.' The reference is to the series of fantastic knights in armour (together with ivory-faced, polychrome, female symbolic figures in elaborate Medieval robes and crowns), which he attempted as a *tour de force* of goldsmith's work.

The theme of the knight in armour is delightfully treated by Gilbert Bayes in his *Knight Errant* of 73
1900, and given a touch of whimsicality by the idea of a little army of imps and fairies pulling at the draped caparison on the knight's horse.

With a little effort one can stretch the limit of 'craft sculpture' to include the mother-of-pearl and gesso work of Frederick Marriott. His *Oberon* of 1901 62 combines those irrepressible Edwardian themes of the glamorous knight and a fairy-tale mystery in an irresistible work of exemplary decadence.

CHAPTER SEVEN

TOYS

By the time of Peter Pan's creation in 1904 there was little doubt that the Edwardian age was a golden one for children.

Barrie's creation of the boy who was never to grow up because adult life was so much less attractive, typifies a shift of attitude. Children were no longer to be seen and not heard. They had been lifted from their sombre and gloomy Victorian playrooms to be revered as symbols of innocence.

If it was a golden age for children, it was equally rich for toy-makers. British manufacturers gained a significant lead over a former German monopoly. In the manufacture of toy soldiers, for example, the firm of William Britain was producing twenty varieties in 1895. Within ten years they were casting five million soldiers from over one hundred moulds.

Prosperity brought improvements such as articulation and standardisation. Standardisation to 'O' gauge, which was the suggestion of no less a player of games than H. G. Wells, brought the new toy soldiers into scale with the latest mechanical train sets.

The name of Mr Frank Hornby is virtually synonymous with mechanical train sets, though Tri-ang have since won a large proportion of this market. Few people would know, however, that Mr Hornby is also the father of 'Meccano'. In 1901 he patented a toy 'Mechanics Made Easy' which was christened 'Meccano' in 1907. The year 1901 saw also the introduction of the first quality toy steam locomotive by Bassett-Lowke. Bassett-Lowke crops up in another context in the study of Edwardiana. He had his Northampton home drastically redecorated by Charles Rennie Mackintosh in 1916.

The more adventurous boy would have been very tempted by the working model aeroplanes that started to appear even before the first real plane had flown successfully.

The market was not exclusively boy-orientated, and many delightful dolls survive from the Edwardian period. Either of wax, or their bodies stuffed and covered with soft leather below a porcelain face, these dolls were generally most elaborately dressed and lavishly provided with frilled parasols and vast rambling hats.

Some English and American dollmakers began to compete with their German rivals, but the Germans had the monopoly in china dolls' heads for many years to come and were exporting them to England in a big way throughout the Edwardian era.

Dolls' houses were mass-produced at the beginning of the twentieth century and relatively cheap to buy and dolls house pieces could be bought for 1d. each. Queen Mary exhibited many elaborate dolls' houses which aroused a new interest in grown-ups as well as children. 'Titania's Palace', made by Sir Nevile Wilkinson for his little daughter in 1907, reached extravagant heights but was never really intended as a plaything.

In 1912 the Kewpie all-bisque baby dolls with their upswept hair and huge soulful eyes, became fashionable and were produced as soldiers, farmers, firemen, and so on.

The best toy shop was Hamley's. Cremer's, Ellisdon's or Davenport's were also popular.

Miss Florence Upton published in 1895 her children's book, *The Adventures of Two Dutch Dolls and a Golliwog*. The hero was to give his name to possibly the first, and one of the most popular, 'named' soft toys.

74 Wendy gently kissed his cheek. *Illustration by Alice B. Woodward from* The Peter Pan Picture Book, *a volume issued in 1907, with J. M. Barrie's assent to revive memories of the play.* British Museum, London.

75 *Pedal car made in 1914*
by the estate carpenter of a family.
Rottingdean Toy Museum, Sussex.

76 *Mechanical toy aeroplane made in 1908.*

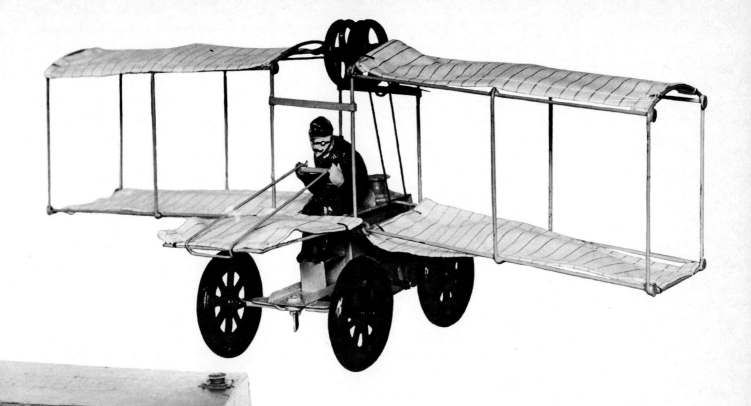

Next on the scene came 'Teddy' bear. He first 79 appeared in 1903, quite by chance, as the result of a cartoon by Clifford Berryman in the *Washington Post*. The cartoon followed a photograph of President 'Teddy' Roosevelt after a bear hunt in the Rockies with a brown bear cub at his feet.

'Teddy' bear appeared simultaneously in America, manufactured by the Ideal Toy Corporation under Morris Michton, and at the Leipzig Toy Fair of 1903, manufactured (with rather longer limbs) by the German toy-maker, Margarete Steiff. Before long the British were producing their own bears, tending to squatness but with the luxury, after 1908, of a built-in growl.

Edward VII's reign closed with a rather sad toy. The dog 'Caesar', who had marched in his master's funeral, appeared in 1910 as a model with a notice about his neck: 'I am Caesar; I belong to the King'.

Great thought was given to the rooms which would house these toys, together with the cherished child.

It was not unusual for the child of a wealthy family to enjoy a suite of rooms, usually at the top of the house, including day and night nurseries, playroom, bathroom, perhaps even his own kitchen.

Special children's furniture was made, cots, tables, chairs, and so on, usually in pale woods, or painted white, or in pastel tones. Naïve stencilled decorations were popular for walls as well as furniture. An article on 'The decoration of the night nursery' from *The* 78 *Lady's Realm*, November 1905, having explained how children have a wonderful inborn sense of imagination, suggests that 'To satisfy this poetic sense, no better form of decoration could be devised than simply drawn fairy tales.'

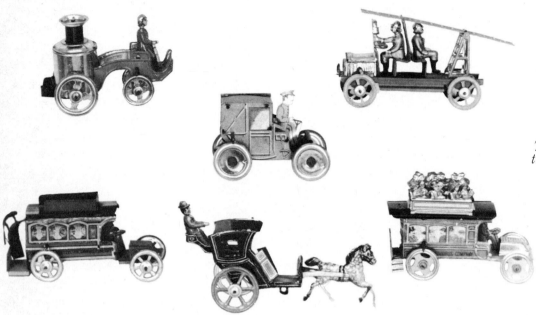

78

79

80 Black Prince, *a model engine made in 1902 by Bassett-Lowke Ltd, who are still making model railways today.*

81 *Toy soldier box which contained models of all the different soldiers of the British army, about 1900 London Museum, London.*

81

THE MUSIC HALL, MUSICAL COMEDY
AND EARLY RECORDING

THE EDWARDIANS did not have the luxury of television to distract them. Nor did they have the cinema as a fully developed form of entertainment. The theatre, therefore, was the greatest medium of popular evening entertainment. The Edwardian public was hardly receptive to new heavy drama from abroad, nor indeed did new home-grown serious drama find great welcome. Shakespeare was always popular, however, since familiarity with the subject-matter meant that *Macbeth, Hamlet* or *A Midsummer Night's Dream* could without difficulty be absorbed into a family outing to the 'West End'. It was sufficiently exciting to compare performances over dinner, and certainly less taxing than considering the latest from Ibsen or Chekhov.

The greatest manifestation of Edwardian taste in the theatre was the music hall, known in America as 'Vaudeville', and musical comedy. The former orientated more towards the working class, the latter towards the middle class and lazy upper class. The music hall offered an evening of variety: song and dance routines, jugglers, acrobats, short sketches, comedy turns, often highly slapstick in style (the early cinema comedies of Charlie Chaplin or Laurel and Hardy were born in the music hall), or the popular male impersonators, Vesta Tilley, Maggie Duggan, Hetty King. An evening at the music hall would close with a few flickering minutes of silent film, known at that time as the 'biograph show'. The music hall's strength resided in the fact that for every one of London's top West End shows at the Alhambra, Empire, Palace or London Pavilion, there were dozens of lesser shows in every town throughout the country. Acts could be polished in provincial tours before reaching the London stage. This was a great, popular theatrical form—an important folk art. The music hall also provided its largely male audience with a leg show.

The musical comedy went further, in that, as well as providing a dazzling chorus line, it was also managed as a powerful vehicle for projecting and publicising 'stars'. The stage provided the only hope of achieving fame, fortune and all that goes with it to an attractive young woman not born into 'society'. Shrewd managers capitalised on the ambitions of their stars and the tastes of their audiences. The *Gaiety Girl* in two words almost resumes the musical comedy. This play established a popular precedent in 1892. Lavish productions followed with such titles as *A Greek Slave* (1893–4), *The Shop Girl* (1894), *An Artist's Model* (1895), *The Circus Girl* (1897), *The Belle of New York* (1897) (the first show to be successfully brought to the London stage from New York, and starring Edna May), *The Runaway Girl* (1898), *The Girl from Kay's* (1902), *The School Girl* (1904), or *The Quaker Girl* (1909–10) starring Gertie Millar. These productions, in addition to the title part, would boast a chorus of up to forty girls. George Edwardes, the great impresario who created the 'Gaiety Girl', would select the loveliest of his frothy young ladies for front-line display, and these would be known backstage as the 'Big Eight'.

A rival actor-manager, Seymour Hicks, launched the rather more aloof 'Gibson Girls' on the London stage. The American cartoonist, Dana Gibson, had drawn his ideal woman, and in 1904 a much publicised contest in New York selected Camille Clifford as the girl who most successfully embodied the attributes of the original cartoon. Her high-piled hair, daring neckline, excruciating waistline and her haughty looks became as fashionable as her song *Why do they call me a Gibson Girl?*

Many song-sheets, theatre programmes, posters and post-card pin-ups survive to remind us of this era. Through this mass of ephemera, various fashionable themes can be traced. An obvious one is the taste for the Oriental. One finds a great deal of cherry blossom, Japanese fans and parasols, stage stars dressed as Geishas, Marie Lloyd as the 'Japanesey, free and easy tea-house girl!' and a host of

82 A Gaiety Girl,
theatre programme by Dudley Hardy, 1894.
John Culme Collection.

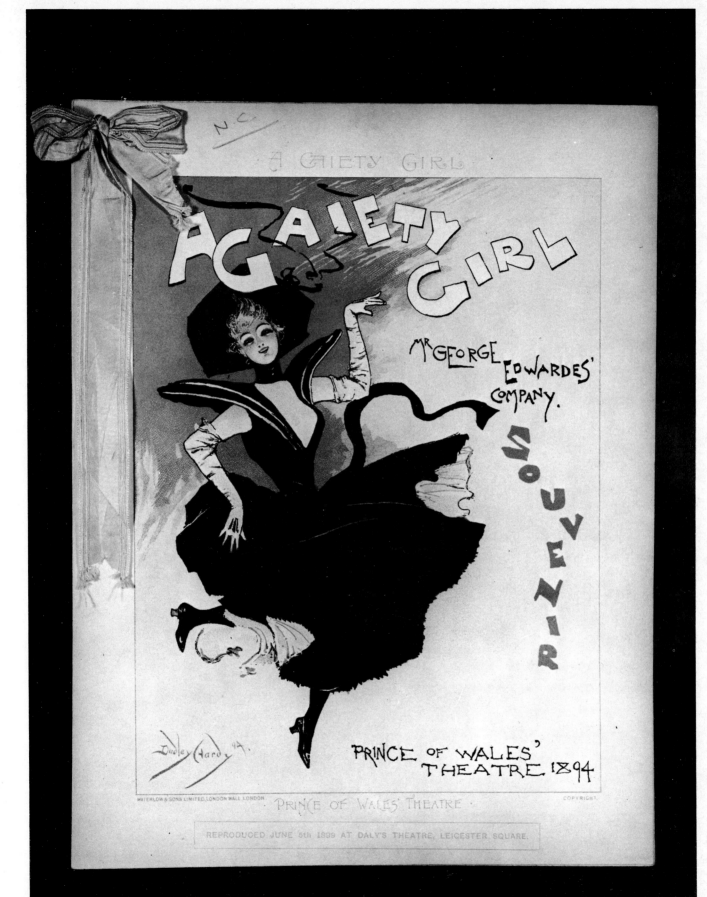

titles, in the tradition of the *Mikado* such as *The White Chrysanthemum* (1905); *The Mousmé* (1911); *San Toy* (1899); *The Cingalee* (1904) or *The Chinese Honeymoon* which ran for a record one thousand performances at the Strand between 1901 and 1903, starring Louie Freear, Lily Elsie and Marie Dainton. The Anglo-Japanese Alliance of 1905 could only have encouraged this taste.

Two theatrical occasions, each in its own way a shock treatment, heralded the end of the Edwardian musical comedy and music hall. In 1911, to celebrate the Coronation, the Diaghilev production of *Scheherezade* was brought to London. This extravagant and sensual ballet, decorated by Leon Bakst and starring Nijinsky, in its frenzied tale of harem jealousies, triggered a new taste for hard acid colours, rich greens, blues, oranges and purples. The fashionable took to turbans, aigrettes and harem dresses. Even before the First World War the Art Deco style was asserting itself.

Equally potent was the arrival from America of *Hullo Rag-Time*. Brought to the Hippodrome in 1912 by Albert de Courville, the show starred Ethel Levey, a singing star with a resonant voice capable of tackling the gutsy, zestful, negro-inspired music backed by saxophones, trumpets and trombones. The chorus line was led by Shirley Kellogg playing a drum and showing plenty of leg. The genteel musical comedy never recovered from the impact of Irving Berlin's syncopated rhythms.

While the Edwardian age was enjoying the final flourish of the music hall as a popular entertainment, pioneers were toying excitedly with two new media of entertainment with an even wider potential appeal. The growth of the cinema and vocal recording industries are characteristically Edwardian.

The first disc vocal recording in London was made in 1898. This had been anticipated by the Americans, who had recorded the earliest *Berliners*, sung by Maurice Farkoa, George Gaskin, John Terrell and George Johnson in 1895. The quality of these first attempts was, by modern standards, fairly crude, and it was this poor reproduction, combined with the fact that to collect and play records was a horribly

84 *Frank and Marguerite Gill performing the*
Brazilian Maxixe at the Criterion theatre,
January 1914.

4 Find Weg drumming and Golliwogg bound. L.C.

LADIZMAN THE CHIEF.

16

GOLLIWOGG DROWNING.

16

THE PRISONERS.

2 Find the African & Sarah Jane and Golliwogg & Peg at the Ball. L.C.

THE MAGNATE FROM JAPAN.

11

MAKING BISCUITS.

4

GOLLIWOGG BOUND.

6 Find Black Servant and Sarah Jane bathing. L.C.

GOLLIWOGG BATHING.

3 Find Peg and Sarah Jane Cycling, and the Bun Cart. L.C.

GOLLIWOGG SAWING.

8

GOLLIWOGG TRENCHING.

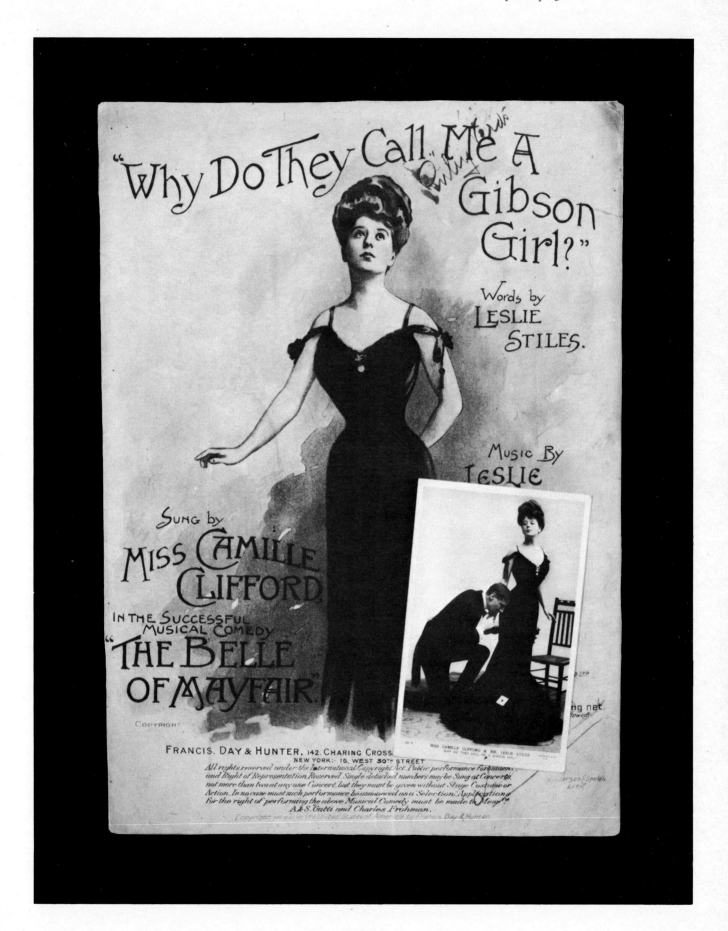

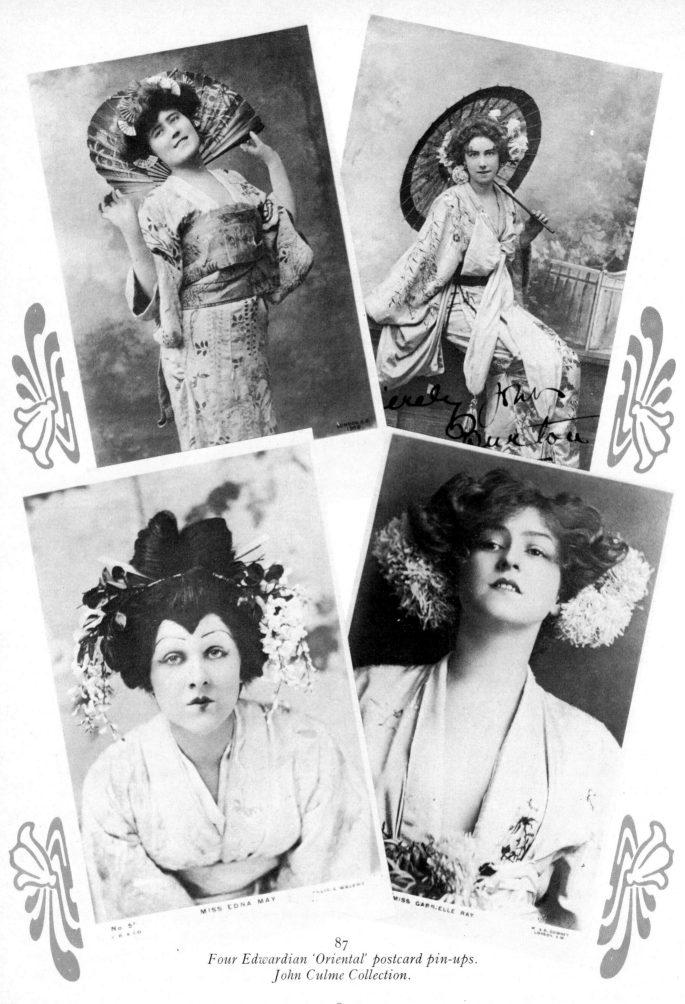

MISS EDNA MAY

MISS GABRIELLE RAY

87
Four Edwardian 'Oriental' postcard pin-ups.
John Culme Collection.

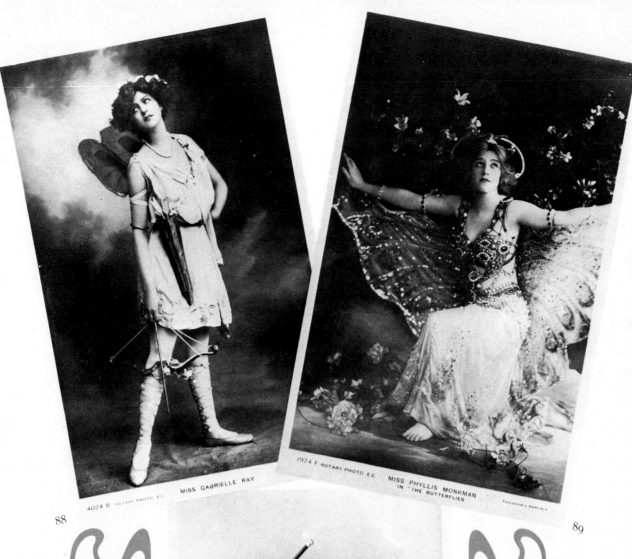

88 *Miss Gabrielle Ray as a musical comedy fairy.*

89 *Miss Phyllis Monkman exhibiting whimsical Edwardian sex appeal.*

90 *The Golliwog in a musical comedy postcard with Alice Lethbridge, about 1900. John Culme Collection.*

expensive hobby, that made progress difficult. Records were considered a novelty until about 1910 (when, incidentally, the first double-sided discs began to appear on the market). J. B. Priestley, for example, recalls that he did not take this new toy at all seriously and did not consider buying a gramophone until 1919.

Nor was the situation facilitated by the recording artists themselves. Drawn from the ranks of the music halls and musical comedies, many were frightened of putting too much on to disc, as they felt that their audiences would no longer fill the theatres, preferring to enjoy their stars on record in their own homes. The recording studios themselves hardly provided encouragement. The musical comedy artist, Delia Mason, remembers that the tremulous quality of early recorded female voices was not the result of fashion but the result of fear. She describes her first and last recording session early in 1905. It was a duet with Maurice Farkoa, *My Portuguese Princess*; for the first time she was expected to perform without the reassurance of an audience; cramped with the full orchestra into a tiny studio she was given strict instructions to stand beside Mr Farkoa facing a hole in the wall the size of a half-crown; two technicians stood behind the couple, their hands grasping their shoulders and they would tilt the performers forward up to the mouthpiece, as each in turn had a line to sing. Any movement of the artists' feet would have caused background echoes!

Despite all these drawbacks, the Great Caruso was able to become the first million-seller as early as 1904, and the large hand-wound horned gramophone is certainly one of the most immediately evocative objects of the period.

The flickering 'Biograph' shows, which had at the beginning of Edward's reign been appendages to music hall programmes, had, by the end of his reign, virtually ousted the music hall. Shrewd managers created plush 'picture palaces' (this name is itself a good piece of marketing) with carpets, bevelled mirrors, soft lights, 'usherettes' and names full of pomp and promise: the 'Olympia', 'Empire', 'Bijou', 'Pallasino', 'Jewel', 'Gem' or 'Palaceadium'. Progress was not slow and inventors were quick to join this particular bandwagon. Board of Trade figures show that between 1908 and 1912 the number of registered film companies had grown from three to over two hundred, and their gross capital from thousands to millions of pounds.

Queen Victoria's Diamond Jubilee in 1897 had provided one of the very earliest newsreels, and her funeral in 1901 and Edward's Coronation in 1902 reached even larger audiences. The excitement caused in 1910, when the American, Florence Lawrence, was revealed as the star of some of the earliest 'Biograph' features, made it clear that the cinema was a potential star-maker on a scale that could never have been conceived by the impresarios of the musical comedy.

91 *George Edwardes' Gaiety Theatre programme, 1891. Private Collection.*

92 The Geisha. *Music sheet cover, 1896. Private Collection.*

91

THE GEISHA

CHORUS.
Ev'ry little Jappy chappie's gone upon the Geisha—
Trickiest little Geisha ever seen in Asia!
I've made things hum a bit, you know, since I became a Geisha,
Japanesey, free and easy Tea house girl!

Written by CHARLES WILMOTT,
Composed by GEORGE LE BRUNN,

Sung by
MISS MARIE LLOYD.

Copyright.

LONDON. FRANCIS, DAY & HUNTER. 195, OXFORD STREET, W.
Publishers of. Smallwood's Celebrated Pianoforte Tutor. Smallwood's 55 Melodious Exercises, Etc.
NEW YORK. T.B. HARMS & C? 18 EAST 22ND ST.
Copyright MDCCCXCVII in the United States of America, by Francis, Day & Hunter.
H.G. BANKS, Lith.

Price 4/:

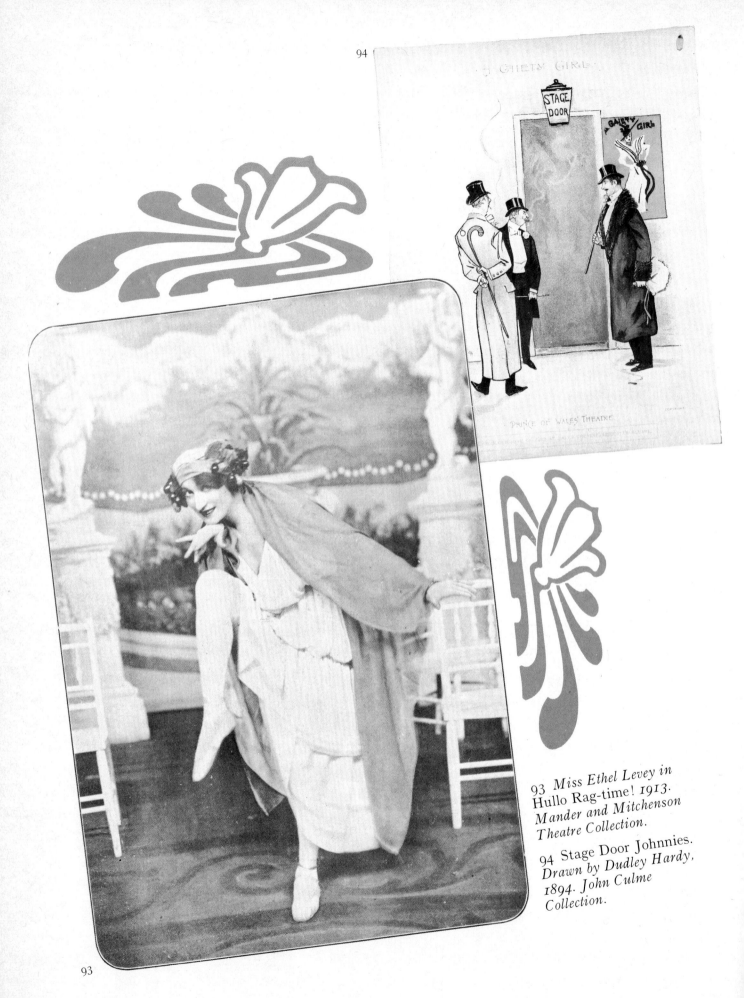

93 *Miss Ethel Levey in Hullo Rag-time! 1913. Mander and Mitchenson Theatre Collection.*

94 *Stage Door Johnnies. Drawn by Dudley Hardy, 1894. John Culme Collection.*

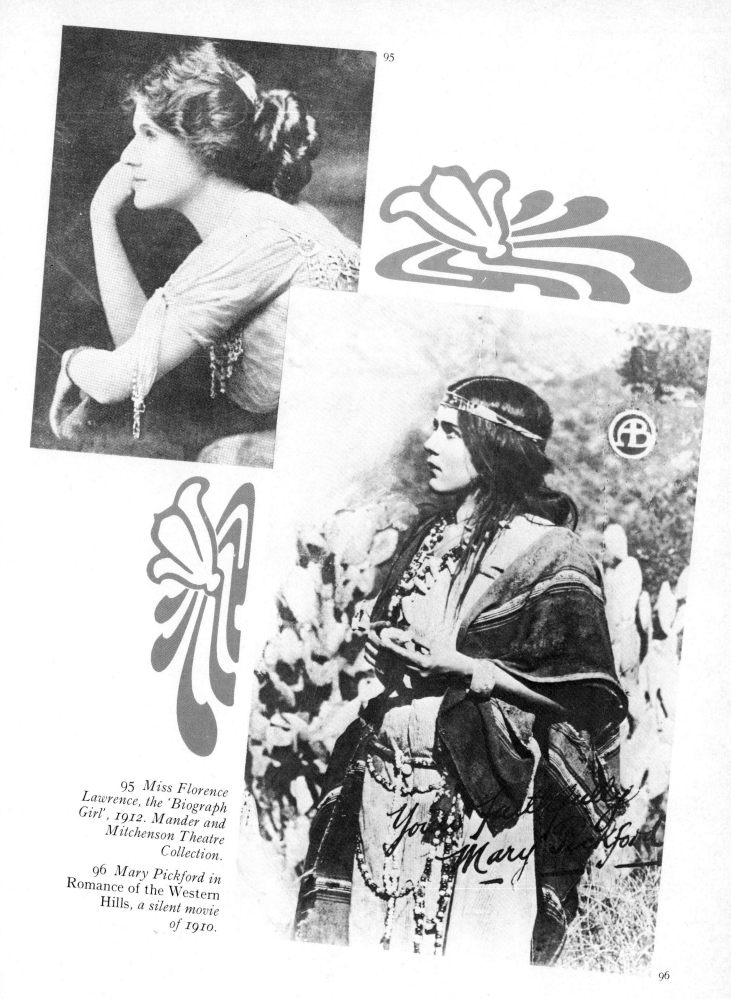

95 Miss Florence
Lawrence, the 'Biograph
Girl', 1912. Mander and
Mitchenson Theatre
Collection.

96 Mary Pickford in
Romance of the Western
Hills, *a silent movie
of 1910.*

POSTERS AND PUBLICITY

DURING THE late 1890s and the 1900s, the success of any new poster could be calculated in inverse proportion to the duration of its exposure on the hoardings. This was no reflection on the incompetence of marketing managers; on the contrary, it was a subtle trick of marketing, for poster collecting had developed from a fad into a veritable mania, and eager collectors would venture forth in the dead of night to peel down examples of the work of their favourite artists. Certain publishers shrewdly added the mystique of limited editions by numbering posters to give spice to the hoarding violators' craze. It was a craze which gave birth to its own esoteric publications of which the monthly journal *The Poster* was the most popular in this country.

The poster as a popular art form was something new to the 1890s, and it was an art form that imposed its own set of standards. For ultimately the idea was to sell a product, and it was the designer's task to emphasise a caption or a brand-name in a striking way without letting his talent swamp the product. The tendency in England and in America was towards a bold graphic stylisation.

Although he was primarily a book illustrator and produced very few posters himself, it would be difficult to over-emphasise the influence of Aubrey Beardsley on the Edwardian generation of poster artists. The turn-of-the-century 'silhouette' style with its dramatic reduction to flat areas of colour within emphatic outlines, and its avoidance of tonal changes within any area, needed the precedent of Beardsley's inspired and dynamic use of line and black/white contrasts. The measure of Beardsley's importance is the number of artists who thought fit to mock as well as to imitate him. The American Claude Fayette Braydon's humour is heavily laboured in his picture of a cloven-hooved lecher leaning to kiss the bursting bosom of a masqued lady while a bat circles above a coshed policeman; this crudely Beardsleyesque work is entitled 'A Wilde Night'! Issue No. 155 of *La Plume* shows a poster in black on yellow which has little quality as a graphic pastiche, yet deserves credit for the artist's *nom-de-plume* of 'Weirdsly Danbery'!

An understanding of Japanese two-dimensional art is implicit in the work of many poster artists. The emphasis on stylisation and abstraction of form, learnt from Beardsley, derives ultimately from Japan. Similarly the poster style of, say, the Beggarstaff Brothers with their heavy outlines or, in France, the posters of Toulouse-Lautrec derive from popular Japanese woodcut prints.

A strong initial impetus was given to the medium of the poster in England by Dudley Hardy's *Yellow Girl*.

97 *Poster design by Duncan Grant, 1912. Victoria and Albert Museum, London.*

98 The Studio, *advertising poster by Léon Solon. Private Collection.*

THE·STUDIO

LÉON·
·V·SOLON

PROFUSELY
ILLUS:
·:TRATED·

AN·ILLUSTRATED·
MAGAZINE·OF·FINE
AND·APPLIED·ART

·ONE·
SHILLING
MONTHLY

Hardy had already immortalised the 'Gaiety Girl' and her 'stage door Johnnies', but according to one contemporary 'The Yellow Girl refused to be ignored ... she was irresistible ...' The *Yellow Girl* took the town by storm. Dudley's creation strutting 'almost immodestly' with a walking stick behind her shoulders in a strong mustard yellow outfit captured the mood of the moment. Her style was more vigorous than that of the precious, feminine creations of the French poster artist, Jules Chéret, with whom Hardy is often compared. This quality of vigour characterises English turn-of-the-century poster art and is well exemplified in the work of John Hassall, a close friend of Hardy. One critic, after describing Hassall's brash and boozy character, explains that the lack of sensitivity apparent in his academic studies was almost an asset to a posterist. Certainly, both these artists worked in a breezy, often gaudy style with more than a streak of vulgarity, yet this is exactly what the medium demanded.

The stencilled silhouette work of the Beggarstaff Brothers (William Nicholson and James Pryde who were, in fact, brothers-in-law) had a graphic directness, though they tended towards more sombre, muted colours.

Nicknamed 'the American B', Bill Bradley produced poster designs which, while showing the influence of Beardsley's style, were never merely imitative. His work is sophisticated and elegant and very 'Art Nouveau' in its linear playfulness, and his poster *When Hearts are Trumps* of 1890 is an advanced exercise in this style. His series of designs for *The Chap Book* helped promote this American equivalent to *The Yellow Book*.

Maxfield Parrish was an immensely popular American illustrator, though his delicate style was

99 The Only Way, *lithographic poster by John Hassal. Victoria and Albert Museum, London.*

100 *Poster by Walter Crane, advertising his own work, about 1906. Victoria and Albert Museum, London.*

101 Don Quixote, *advertising poster design by the Beggerstaff Brothers, 1895. Victoria and Albert Museum, London.*

103 better suited to book illustration than poster design, and his range of subjects was limited. The image recurs with almost obsessive regularity of a pale androgynous youth seated passively, hands generally clasping knees in the soft light filtering through a background of silhouetted trees.

POSTCARDS

An Act of Parliament was passed at the turn of the century which unleashed a vast quantity of what is now collectable Edwardian ephemera. The act made it possible to write a message on the same side of a postcard as the stamp and the address. The result was the picture postcard as we know it today. Subjects ranged from posed sentimental scenes, to ethnographical or social studies. Most popular, and eagerly collected by young women and girls, were the risqué 87,90 pin-ups of music hall and musical comedy stars.

101

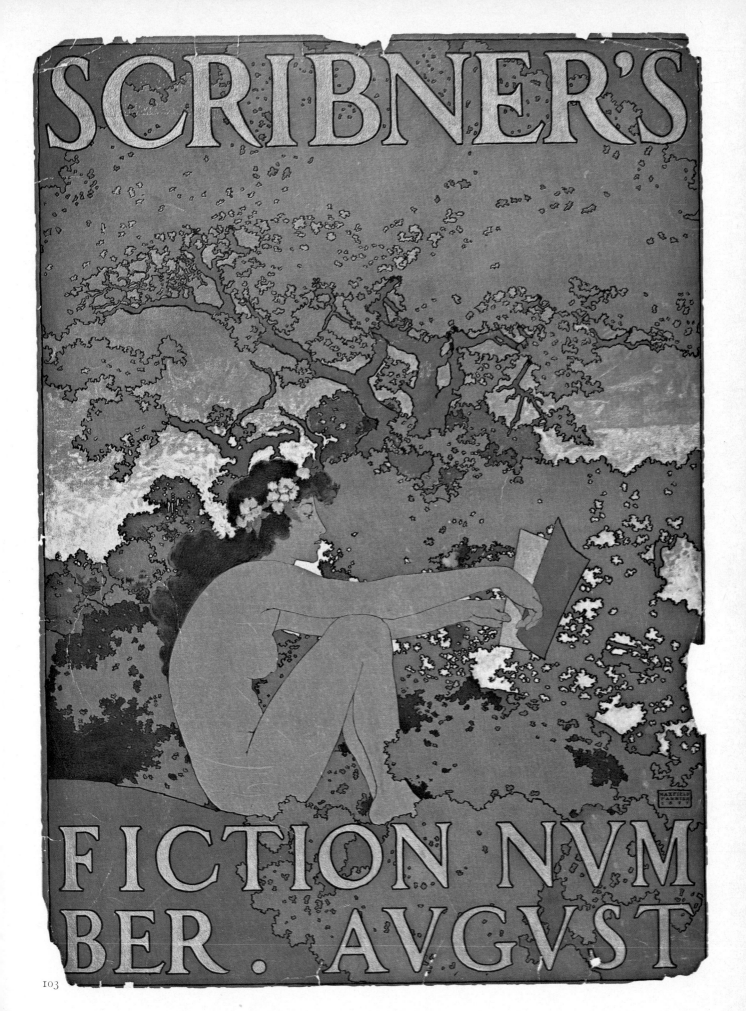

THE DECORATIVE ARTS
SILVER

THE QUALITY of silver production had in general reached a depressingly low standard by the end of the nineteenth century. Large, industrialised concerns in Birmingham, London, Sheffield and Chester were mass-producing items of silver or of the now all-pervading plate. Most were stamped out in presses. In style this commercial silver was imitative, plagiarising with little feeling. Pugin had, early on, regretfully labelled this hotchpotch style 'the Sheffield eternal'.

Concession to fashion was made by stamping out buttons, buckles, dishes, and so forth, with crude profiles amid arabesques of hair or stylised plant forms in a debased version of Continental Art Nouveau. Such silver is in no way representative of the Edwardian spirit!

The picture was not entirely gloomy, however, for there was a new generation of silversmiths emerging which was not shackled by traditionalism, and whose legacy is an original and inspiring selection of silverware. A study of the general characteristics of Edwardian silver reveals certain distinct trends.

The first obvious trend is in the respect given to the medium itself. The new silversmiths exploited the intrinsic sensuousness of silver, emphasising its tactile qualities by a courageous use of plain surfaces, giving it a warmth and a softness by hand-hammering or endowing it with a mercuric, liquid quality by combining smooth, polished surface with fluid form and decorative detail.

Victorian silversmiths, especially during the 1850s and 60s had become involved with texturing the surfaces of their silver. Their mechanical matting, frosting or oxidisation processes, however, were far removed from the hand-wrought qualities of Edwardian silver and tended to conceal rather than expose the metal.

A second characteristic was the eagerness to add colour to the silver. Credit for reviving the art of enamel for use with silver must be given to Alexander Fisher; the fashion soon spread and most major Edwardian silversmiths used enamels at some stage.

The most usual colours for the enamel were shades of turquoise, blue and green; a fiery orange/red was also quite popular. Liberty & Co. were foremost in using blue and green enamels as a background to throw abstract decoration into relief. Many designers set entire decorative enamelled allegorical or landscape scenes into their work. Ramsden and Carr and the Guilds of Handicrafts Ltd produced caskets decorated in this way. Colour was further added by the incorporation of cabochons. Conforming to the prevalent taste for blue and green, the silversmiths often chose turquoise or chrysoprase; areas of mother-of-pearl, perhaps in conjunction with other stones were also fashionable. The cabochons would be incorporated, either to relieve the severity of an unbroken surface or as finials.

Finally, there were new trends in form and decoration. The Medieval was well captured by Ramsden and Carr with decorative rose branch scrolls that call to mind the borderwork in Beardsley's illustrations for the *Morte d'Arthur*. Roses were also favoured by Gilbert Marks, though his treatment of these motifs was much freer than Ramsden's. More important than these or other romantic motifs such as the whimsical galleon, were the new abstract linear decorations. Their boldness, more especially when applied to the new futuristic shapes, was both original and elegant.

The parent of Edwardian silver design was Dr Christopher Dresser. One of its mature exponents was Charles Robert Ashbee. This designer was strongly opposed on principle to the extravagance of Art Nouveau. After visits to the Continent, however, and after exhibiting abroad, the language of Continental Art Nouveau had left a sufficiently strong mark on his work for him to use elegant whiplash motifs. By 1896, when he registered his first silver mark, his creations were, as a result, more stylish and less

104 Liberty & Co. A 'Cymric' silver vase designed by Archibald Knox, inset with turquoise matrix, 1902. Sotheby's Belgravia, London.

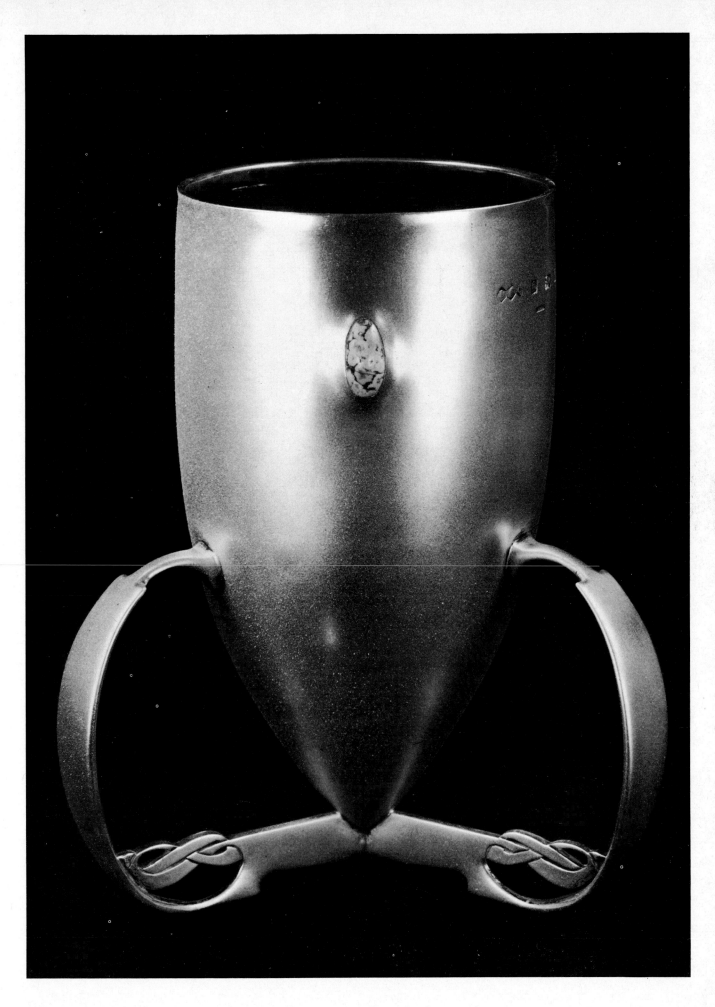

105 *Peacock sconce designed by Alexander Fisher.*
Various metals and enamel, about 1899.
Victoria and Albert Museum, London.

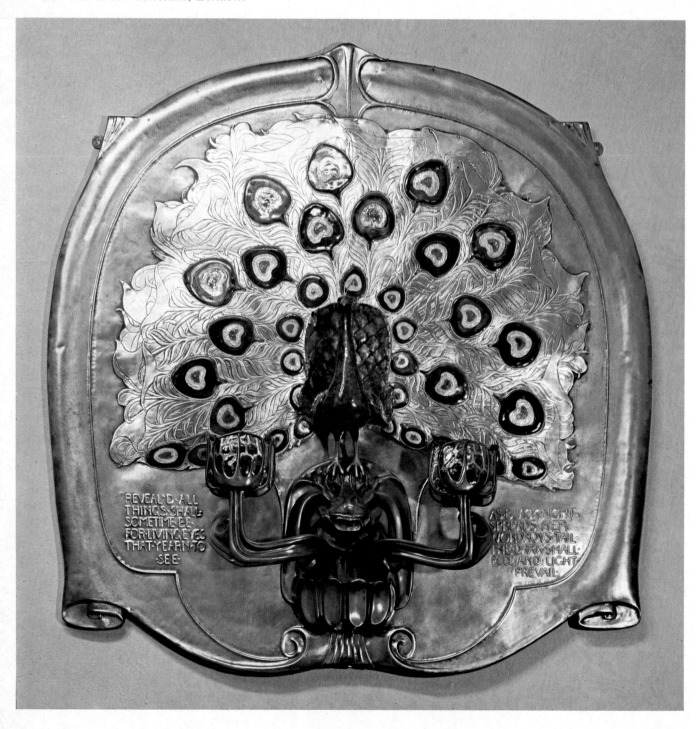

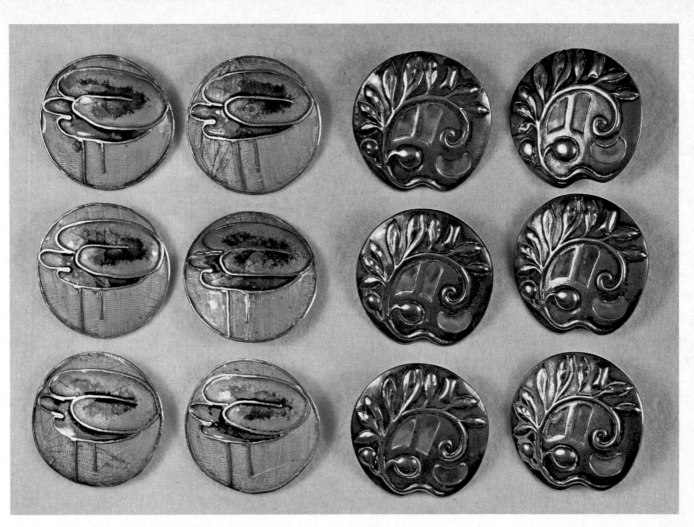

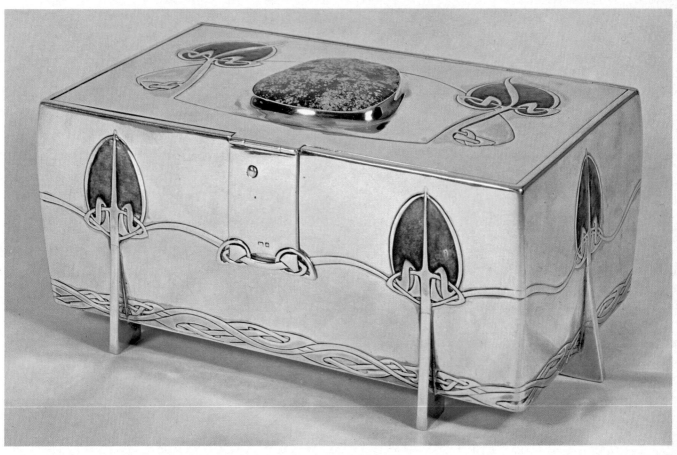

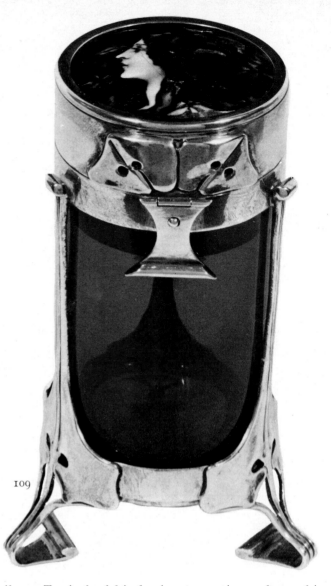

108 *A silver mustard pot designed by C. R. Ashbee for the Guild of Handicraft. Set with four chrysoprase and with a green glass liner. London, 1903. Sotheby & Company, London.*

109 *Scent bottle in silver, enamel and green glass by Kate Harris, designer for William Hutton & Son, suppliers to Liberty & Co, 1901. Sotheby & Company, London.*

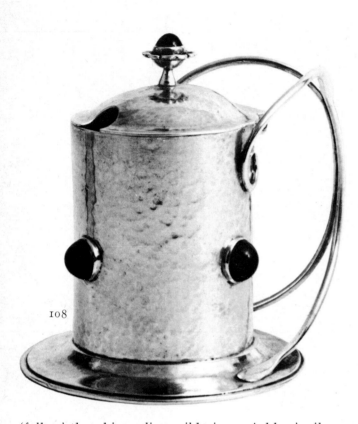

108

109

'folksy' than his earlier guild pieces. Ashbee's silver is distinctive for his use of dividing wire threads sweeping up as handles or embracing pots or decanters. The loop-handled butter dishes of the type illustrated are perhaps his most celebrated pieces.

Omar Ramsden, together with Alwyn Carr, registered his mark in 1898 and continued to design silver, alone or in partnership with Carr, until his death in 1939. They were great advocates of the hand-beaten surface and stylised plant decoration. Their fondness for the rose branch has been mentioned, as has their use of enamel insets. Thistles occasionally adorn their creations, which, incidentally, usually bear the delightful inscription: 'Omar Ramsden et Alwyn Carr me fecerunt.' Omar Ramsden openly acknowledges Holbein as a source of inspiration for his decoration (is Ramsden's rose a Tudor rose?). The Tudor element in his work becomes indisputable when one sees the series of silver and maplewood mazers which he designed, based on Tudor originals.

William Benson of the Art Workers' Guild designed hollow-ware to be made in copper electroplate or silver. Typical of his basic, domestic work are his wicker-handled kettles on stands. Gilbert Marks, A. E. Jones and W. S. Hadaway each produced relevant pieces, though not with the consistency of other makers.

Some of the most beautiful silver produced during the Edwardian period was the 'Cymric' range, manufactured for Liberty & Co. The range, Liberty's first serious venture into silverware, was launched in 1899. The Celtic trade name 'Cymric' was chosen to acknowledge the Celtic inspiration of so many of the designs. For a very direct relationship exists between the motifs of Liberty silver and the delicate, organic interlaced patterns to be found in traditional Celtic illuminated manuscripts, such as the Book of Kells, or on Manx, Celtic and Norse crosses. Celtic art was not the exclusive source of inspiration; Shirley Bury, in her study, *The Liberty Metalwork Venture*, finds 'traces of the Japanese in some of the buckles and other items of jewellery, of Henri Van de Velde's angular functionalism in cravat pins and brooches, of the *Jugendstil* in certain of the emphatic lines of the bowls and cups'. This silver, enhanced by its brilliant enamels, proved an immediate success. By

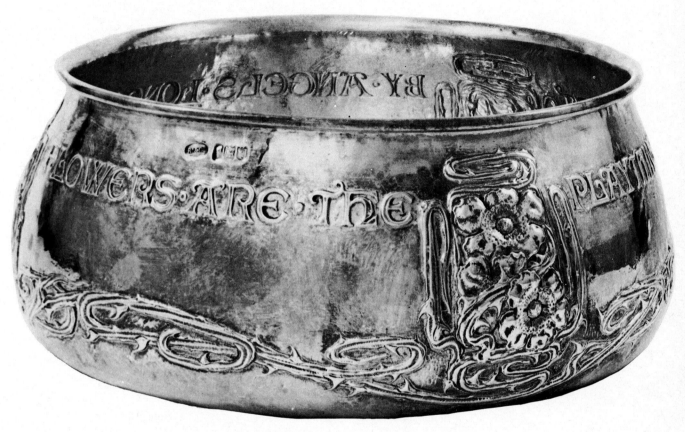

the middle of 1901, production was expanded with the establishment of new workshops in Birmingham under the old firm of W. H. Haseler. A new company 'Liberty and Co. (Cymric) Ltd' was registered at the Board of Trade on 17th May, 1901 with W. R. and Frank Haseler as directors. The success of this venture was to survive until Liberty and Co. (Cymric) Ltd was finally wound up in 1927. (The 'Tudric' pewter proved just as popular and only vanished when in 1939 all but four of the remaining moulds were melted down to help the War effort!)

'Cymric' silver evidently captured a fashionable market. Although Liberty & Co. maintained a policy of anonymity with regard to their designers, it has been possible to discover details concerning the more important of these. It is not surprising to find that a very youthful group was responsible for the silver. When it was launched in 1899, Bernard Cuzner was twenty-two years old, Jessie M. King, the Glasgow School illustrator who designed jewels for Liberty was twenty-three, Rex Silver was only twenty, whilst Archibald Knox, who produced a total of over four-hundred designs for the company, was the oldest at thirty-five!

The American silversmiths of the late nineteenth and early twentieth centuries were too concerned with evolving a distinctive national style to be receptive to the ideas of the more drastic modern British silversmiths.

American silver enjoyed no Arts and Crafts influence, and its character was based on a—one hopes—controlled eclecticism in which Middle Eastern as well as Baroque, Rococo and Neo-Classical elements can be traced. One concession to modern European taste was the incorporation, after the 1870s, of Japanese features in decoration. Stylised fish and seaweed can be found on silver vases by Tiffany and Co., their form based on Japanese tusk vases.

Tiffany and Co., founded by the father of Louis Comfort Tiffany, the glass-worker, were possibly the most significant manufacturing company. Their reputation was based on the high standard and intricacy of their workmanship. As early as 1867, the company was the first foreigner to win the first award at the Paris Exhibition. Edward C. Moore, who joined forces with Tiffany in 1868, was a strong creative influence as manager of manufacturing interests till

111,112 *'Clutha' glass vases designed by Dr Christopher Dresser for James Couper and Sons, Glasgow. Each vase bears designer's and maker's mark, 1890s. Private Collection.*

111

113 *Glass vases by Louis Comfort Tiffany, including rare red and black glass and a small lava vase, about 1900.*

114 *Decorative stained glass window designed for a seaside villa, 1908. By courtesy of Selina Paget-Baxter.*

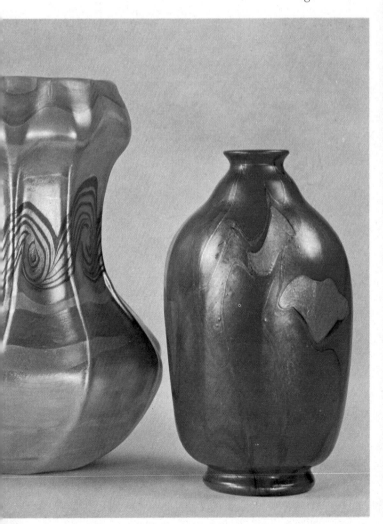

his death in 1891. This outstanding vase, produced under his successor, John Curran, for the World's Columbian Exhibition in 1893, represents many of the ideals that Tiffany and Co. stood for. A contemporary article emphasises the basic American character of the piece: 'The Magnolia vase . . . is purely American; its form was suggested by the pieces of pottery found among the relics of the ancient cliff-dwellers of the Pueblos. The eight handles around the neck are Toltec, these together represent the early Americans. The decorations are composed of flowers and plants representative of the north, south, east and west, making the vase in its entirety a characteristic American piece.' Its unashamed opulence is typical. The use of conglomerated long-petal flowers is distinctively American, whilst the peacock-feather base represents influences assimilated subconsciously from the English.

A few American firms did consciously attempt an Art Nouveau style. The Gorham Manufacturing Company of Providence had a range called 'Martelé' (hand-hammered), first marketed about 1900 and designed by an Englishman. The Unger brothers of Newark produced commercial desk and personal ware with fluid maidens, plants or waves as decoration. S. Kirk and Son, and Reed and Barton were more traditional.

115 Commercial silver. A typical mid Edwardian advertisement of the usual run-of-the-mill objects in popular mass-production. John Culme Collection.

116 Silver and enamel mirror by William Snelling Hadaway, set with turquoise and chrysoprase. Illustrated in The Studio, *London, 1904. Sotheby's Belgravia, London.*

Mappin & Webb's PRESENTS IN STERLING SILVER AND PRINCE'S PLATE.
(Regd. 71,552.)

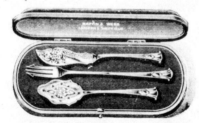

Sterling Silver Salt Cellars and Spoons, in Morocco Case. Case of Four, £2 2 0 | Case of Six, £3 0 0

Registered Design. Jam-Spoon, Pickle-Fork, and Butter-Knife, in case. Prince's Plate, 15s. Sterling Silver, £2 2s.

Gentleman's Sterling Silver Card-Case, richly Engraved, £1 11s. 6d. Ditto, Plain, £1 7s. Complete in Morocco Cases.

Two Sterling Silver Mufineers, Fluted, in rich Morocco case, lined Silk and Velvet, complete, £2 5s.

WRITE FOR THE SPECIAL LIST (50 ILLUSTRATIONS). POST FREE. GOODS SENT TO THE COUNTRY ON APPROVAL.

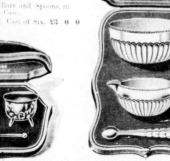

Two Sterling Silver Salt Cellars, Spoons, and Mufineer, in best Morocco Case, £1 13s.

Registered Design. Handsomely Fluted Sterling Silver "Princess" Sugar-Bowl, Cream-Jug, and Sugar-Tongs, in Morocco Case, £2 15s.

Gold Cigar Cutter, in Case, £1 5 0
Silver ,, ,, 0 13 6

Six Afternoon Teaspoons and Tongs, in Morocco Case, Prince's Plate, £1 8s. Sterling Silver, £2 2s. *Registered Design.*

ONLY LONDON ADDRESSES
158 to 162, OXFORD STREET, W.; and 2, QUEEN VICTORIA STREET, E.C.
Manufactory: ROYAL PLATE AND CUTLERY WORKS, SHEFFIELD. (facing the Mansion House).

115

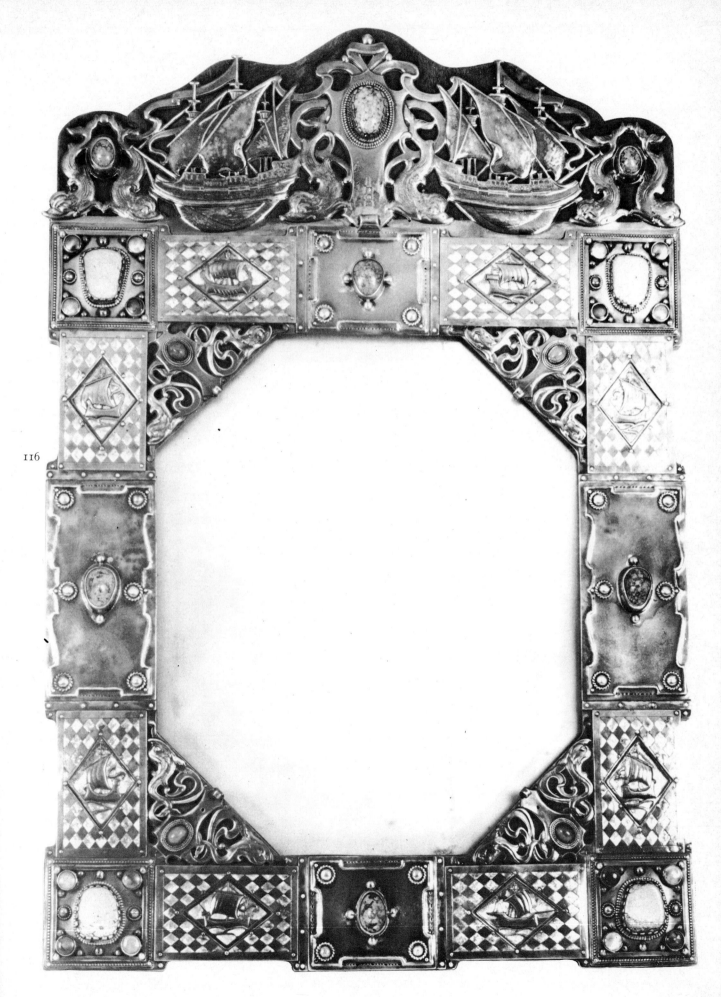

116

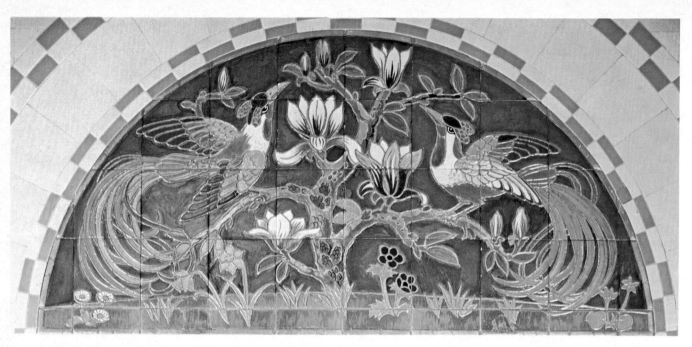

117 Birds of Paradise. *Tiles designed by William Neatby for the Food Halls at Harrods, London, 1904.*

118 *Ruskin pottery. A group of fine pieces with flambé glaze by William Howson Taylor. Private Collection.*

119 *Liberty & Co. A
'Tudric' pewter vase with
glass liner, about 1905.
Sotheby's Belgravia,
London.*

120 *Liberty & Co. A
'Tudric' pewter bowl
designed by Rex Silver,
about 1905. Sotheby &
Company, London.*

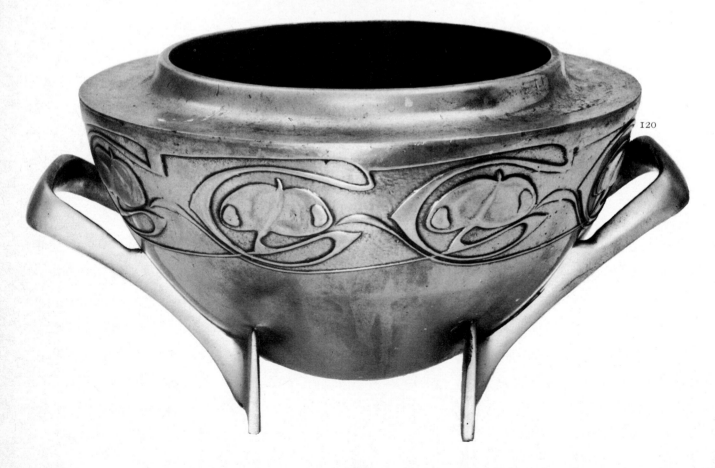

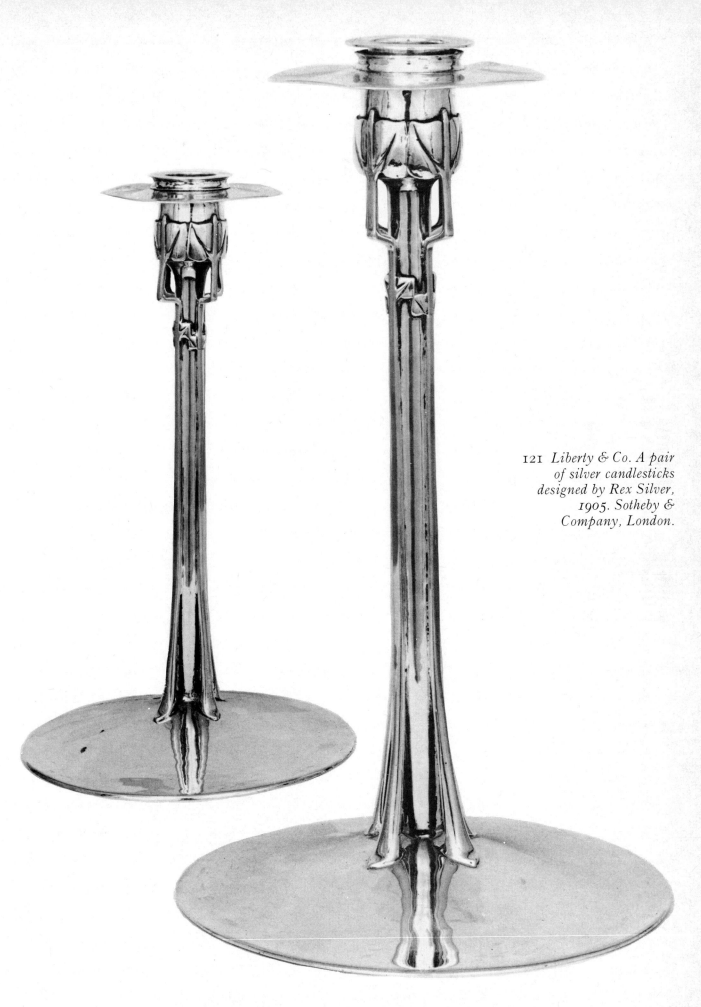

121 *Liberty & Co. A pair
of silver candlesticks
designed by Rex Silver,
1905. Sotheby &
Company, London.*

122 *A fine Pilkington Royal Lancastrian dish*
decorated by W. S. Mycock. The body is dated 1907,
the decoration 1918. Private Collection

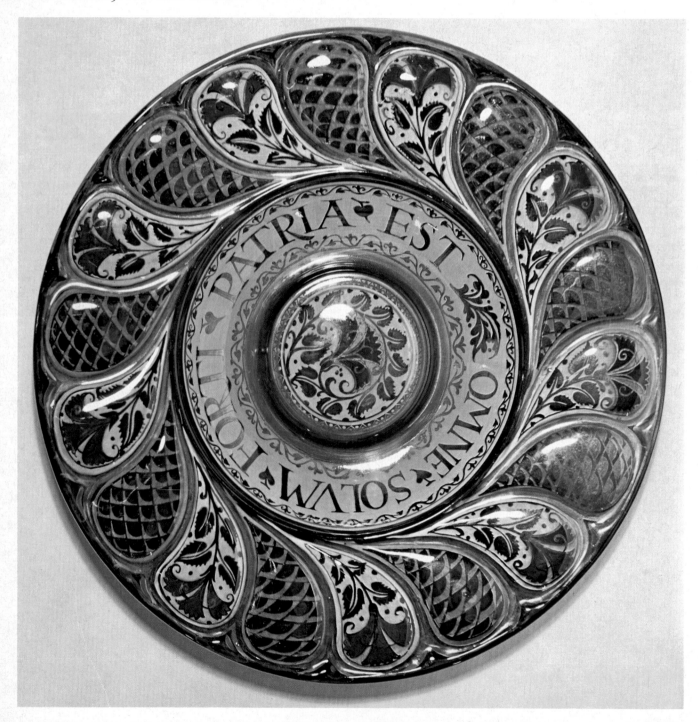

GLASS

ANYONE TAKING breakfast at Tiffany's in New York might be intrigued to learn that this, the most celebrated and perhaps the most prosperous jewellers' shop in America, had been founded in 1837 on a capital of one thousand dollars as a small stationery and dry goods store by Charles Louis Tiffany in partnership with a friend, John B. Young. They might be further intrigued to learn that Charles Louis Tiffany was the father of Louis Comfort Tiffany, who was to achieve an even greater personal fame around the turn of the century as the creator of the outstanding range of art glass that bears his name.

The turn of the century was a period internationally rich in the production of fine glass. Though the French craftsman, Emile Gallé, is often considered the greatest glass-maker of the period, Tiffany certainly stands out as the most important American, outshadowing anything produced in England by the sheer range and quality of his creations. Louis Comfort Tiffany was born in 1848 and proved something of a disappointment to his father when at the age of eighteen, at the end of the Civil War, he announced that rather than enter the family business he would prefer to study art. He was a romantic with a strong feeling for nature, and evolved as a landscape painter under George Innes—one of the leading artists of this genre. In Innes's studio he was to meet Oscar Wilde and feel considerable sympathy for his aesthetic ideals. He spent the winter of 1868–9 in Paris with Léon Bailly, and together they visited Spain and North Africa. An immediate fascination 124 for Moorish, Islamic and North African art was instilled in the young Tiffany, whose eclecticism was further broadened by his introduction through Edward C. Moore, his father's chief designer, to Oriental art.

Tiffany spent most of the 1870s painting, but was the first to admit his shortcomings; he was easily persuaded by Edward C. Moore to turn his hand to decorative work. 'Louis C. Tiffany and Associated Artists', established in 1879, was a successful decorating partnership, but, fascinated by the coloured glass tiling which he incorporated into schemes, Louis Comfort soon abandoned the venture '... for his wonderful experiments in glass iridescence.'

In the course of his travels, Tiffany had formed a collection of ancient glassware. His particular fascination was with the subtle nacreous lustres achieved as the result of decomposition by oxydisation while the glass lay buried over the centuries. He also saw a beauty in the pitted and corroded effects caused by decomposition, and so he turned his energies towards the mastery of the techniques of glass-making to the point where he would be able to control what were essentially imperfections of surface.

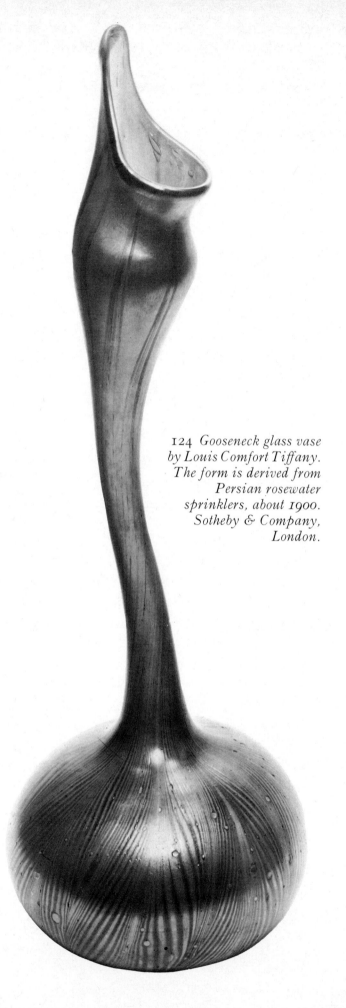

124 Gooseneck glass vase by Louis Comfort Tiffany. The form is derived from Persian rosewater sprinklers, about 1900. Sotheby & Company, London.

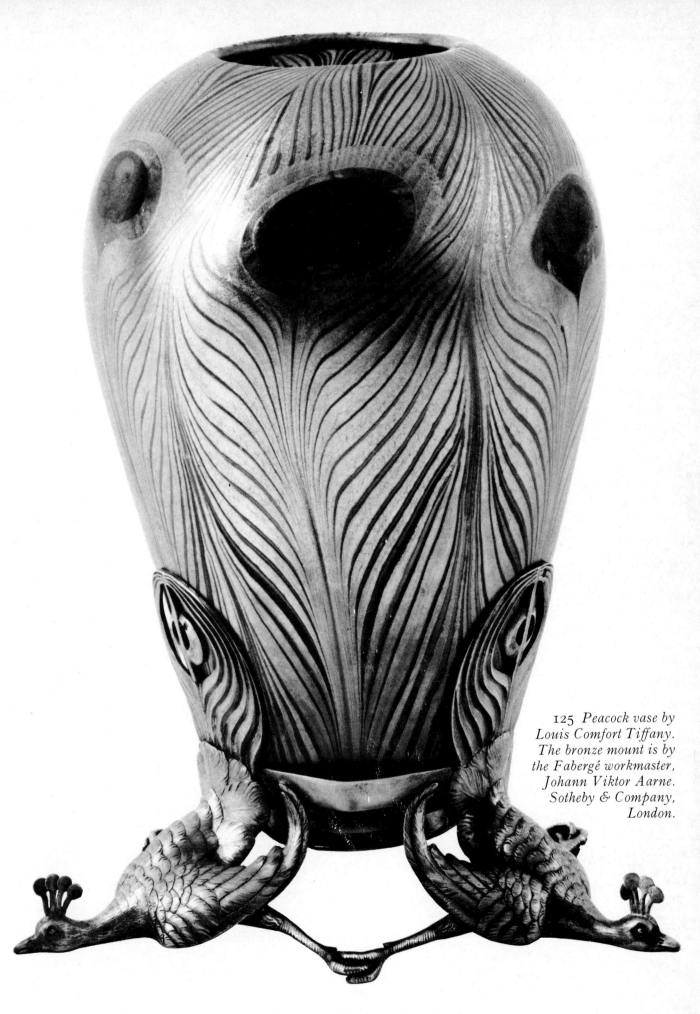

125 *Peacock vase by
Louis Comfort Tiffany.
The bronze mount is by
the Fabergé workmaster,
Johann Viktor Aarne.
Sotheby & Company,
London.*

Tiffany also admired ancient glass for its general simplicity of form, just as he abhorred glassware that was cut or contorted into designs more suited to bronze or silver. The haphazardness and irregularity of ancient glass further attracted Tiffany who, doubtless deliberately, made many vases slightly asymmetrical. His strongest feeling about glass, and on this point he is so very much of his period, was that any decoration or colouring should be an integral part of the glass body and not superimposed. The texture and colours of the glass should in themselves be an adequate visual language.

The demand for Tiffany glass was tremendous, and by 1900 he had a large workshop producing repetitively the gold lustre tableware for which he is perhaps best known. This rather harsh, commercial 'wedding present' Tiffany forms the largest single category, and though every piece bears his engraved name or initials, or the trade name 'favrile' (from the old English expression for 'made by hand') these pieces are very different from the more elaborate glass produced personally by Louis C. Tiffany or under his close supervision. After prolonged experimentation, Tiffany was able to produce lustre glass in peacock blue, the second most popular colour after the gold, and then, in order of frequency, green, white, yellow, brown, amethyst and two very rare Tiffany colours, red and black.

After the plain lustre category (which the Parisian art critic, Samuel Bing, admired in truly *fin-de-siècle* prose for its ' . . . opalised radiations, so subtle, delicate and mysterious that the water of an exquisite pearl can alone be compared to them)' the second, rather rambling category is that of decorated iridescent ware. This group includes vases decorated with a few trailing lily pads and tendrils as well as the more complex delicate, finely veined flower form vases, or superb pieces conceived as groups of fine peacock feathers with multi-coloured striations and inlaid 125 'evil eyes'. The vase illustrated bears the engraved prefix 'o', indicating a special order. It was presented by Tiffany to Prince Michael Cantacuzena, who commissioned Fabergé to make the mount on his return to Russia. A second group demanding great skill and control was that of the 'paperweight' vases in which floral decoration was trapped between layers of the blown glass. The rarest of these incorporate *'millefiori'* glass – canes of coloured glass sliced and embedded between the layers of a vase. The technique is comparable to that of traditional French paperweights, yet Tiffany's achievement is the greater, for he was able to produce his considerable effects of depth within the thickness of the body of a vase.

An ultimate expression of Tiffany's experiments with texture can be seen in his 'Cypriote' glass. Inspired by ancient examples uncovered in Cyprus and the Middle East, these vases have a crusty, gritty surface achieved by rolling the body over a marver covered in pulverised crumbs of glass.

Tiffany's marbleised and agate glass (multi-coloured and polished down to resemble stone) also acknowledge ancient models. An innovation, and very 'Art Nouveau' in its organic quality, was his 'Lava' glass, 113,1 irregular in form and generally with rich gold glass dripping over a blue ground. The critic, Mario Amaya, sees this glass as 'an uncanny precedent to Abstract Expressionism.'

Tiffany wasted no time in turning his energies towards adapting his glassware to the new electric light systems. His solution was a series of floor and 58,12 table lamps incorporating pieces of coloured glass in umbrella-like leaded shades supported on bronze stems. Introduced around 1896–7, these lamps proved so popular that no fashionably decorated home dared be without one. The minute leaded-window effect incorporated glass of various qualities. An ordinary lamp might be almost plain with an even milky green glass. More elaborate lamps would use rippled or laminated glass, various streaked opalescent or marbled glasses or rich orange, purple or red glass in various combinations.

The majority of the lamps were floral in their decoration. Poppies, tulips, daffodils, rambling roses and apple-blossom were popular. The dragonfly lamp designed by Clara Driscoll and exhibited at the Paris Exhibition of 1900 was a great success. Other examples were surmounted by giant spiders, or had bases modelled as clusters of lily pads. Perhaps the most stunning was the 'Wisteria Lamp' designed around 1900 by Mrs Curtis Freschel. This lamp, with its richly colourful steep sides, is very much of the Edwardian period in that its form is its decoration. A Victorian would have created a lamp and applied it with a decoration of wisteria trees. Tiffany has

126

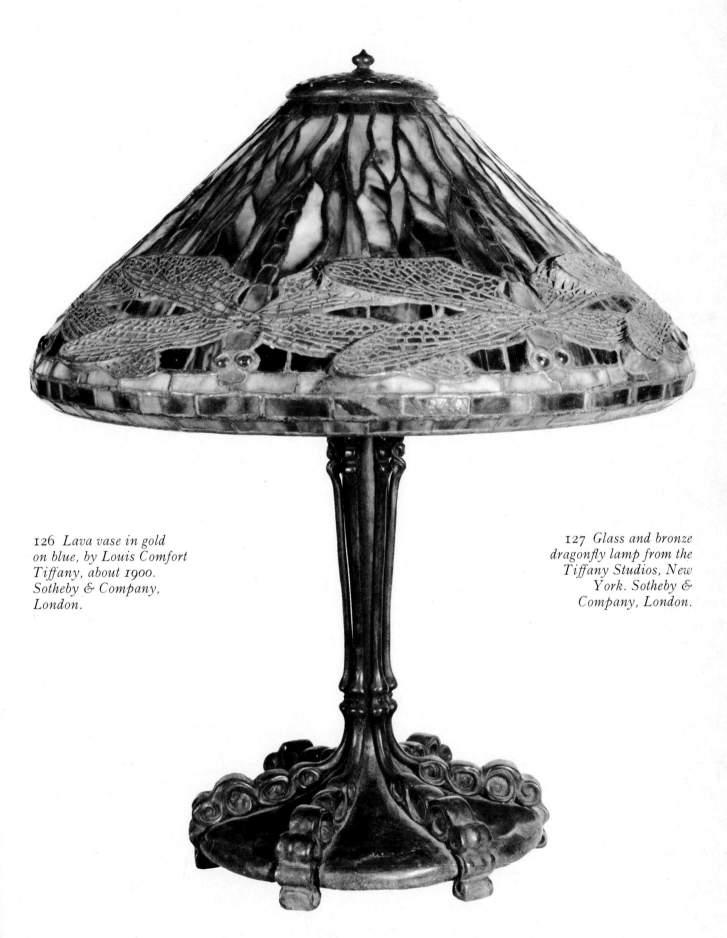

126 *Lava vase in gold on blue, by Louis Comfort Tiffany, about 1900. Sotheby & Company, London.*

127 *Glass and bronze dragonfly lamp from the Tiffany Studios, New York. Sotheby & Company, London.*

gone one stage further and designed a lamp which *is* a wisteria tree.

The Tiffany studio's business expanded during the first decade of this century, and their catalogues offered, in addition to the lamps, ranges of decorative deskware combining fretted bronze with various marbled glasses.

Inevitably Tiffany had his imitators. Handel & Co., incorporated under that name in 1893, and surviving through various changes in management and name long after the First World War, produced a vast range of decorative glassware. Lamps were their most important commodity and, although at their best they could rival Tiffany, their cheaper productions were of a standard that Tiffany would never have accepted. Handel and others made imitation leading with glass domes overlaid in fretted metalwork. The close resemblance of the glass produced by the Quezal Glass and Decorating Company to Tiffany's own glassware is explained by the fact that this company was started in 1901 by two former employees of Tiffany's who, having learnt his secrets, decided to set up on their own. The Steuben glassworks registered the trade name 'Aurene' (from the Latin *aureatus*, 'like gold in resplendence') in 1904.

While Tiffany was rising to new levels of success during the 1890s, English glass production was suffering a decline. A high point had been reached during the 1880s with the fine cameo work of the Stourbridge glass workshops. Stephens and Williams and the firm of Thomas Webb and Sons had won a reputation for their meticulously carved vases, usually with a white overlay on a pink, green, blue or ruby ground. The subject-matter and treatment were very Victorian in mood, and by the 1890s this cameo work was slipping from favour. The name Webb then became associated with the cut-glass for which they are still famous, with a series of acid-etched cameo vases in 'Art Nouveau' taste with coloured glass flowers on a clear body, and with the Burmese glass for which they had taken out a patent in 1887, though this was still Victorian in character.

James Powell and Sons had produced the stained glass used by William Morris and his colleagues, and it was in this Arts and Crafts tradition that Harry J. Powell, during the Edwardian period, designed simple tableware in clear glass, relying on qualities of form for its appeal, and occasionally with simple trailed patterns in green glass to enhance the functional shapes.

Commercial stained glass door or window panels of the type illustrated recur with such frequency that they cannot be ignored, especially as they so often incorporate motifs such as stylised 'Art Nouveau' flowers, or romantic Medieval galleons or castles.

The generally rather uninspiring picture of British glass production was relieved by the Glasgow firm of James Couper and Sons. An article in *The Studio* in 1899 describes and illustrates examples of their adventurous and inventive 'Clutha' glass. This glass takes its name from a Scottish word meaning 'cloudy'. The architect, George Walton, contributed designs for this glass as did the immensely versatile Dr Christopher Dresser, who adapted very well to the demands of this medium. Dresser suggested many novel shapes which enhanced without abusing the sensuous quality of blown glass. Certain shapes rely on ancient models, but the tendency was towards novelty and experiment. The finest pieces signed by Dresser well bear comparison with contemporary American glass. The feathered vase illustrated, with its mellow honey colouring and finely controlled internal decoration, is a superb example of the glass-blower's art. The unrestrained feeling for form in 'Clutha' glass is enhanced by spiralling ripples in the surface, spiralling areas of differing tone, and seemingly haphazard inclusions of silver powder or areas of aventurine (copper crystals).

Dresser and Tiffany can be compared in their eagerness to come to terms with the medium of glass. Dresser's glass, created in the 1890s, has proved his dictum, pronounced in an essay on glass as early as 1870–73, that 'if a material is worked in its most simple and befitting manner, the results obtained are more beautiful than those which are arrived at by any roundabout method of production.'

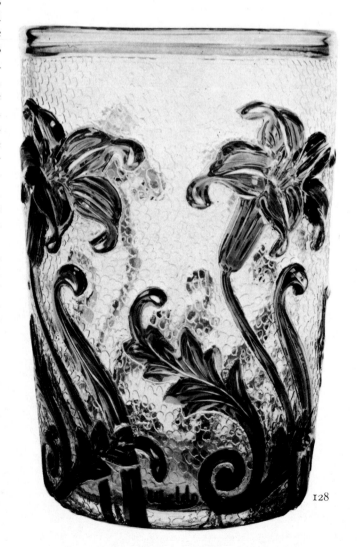

128

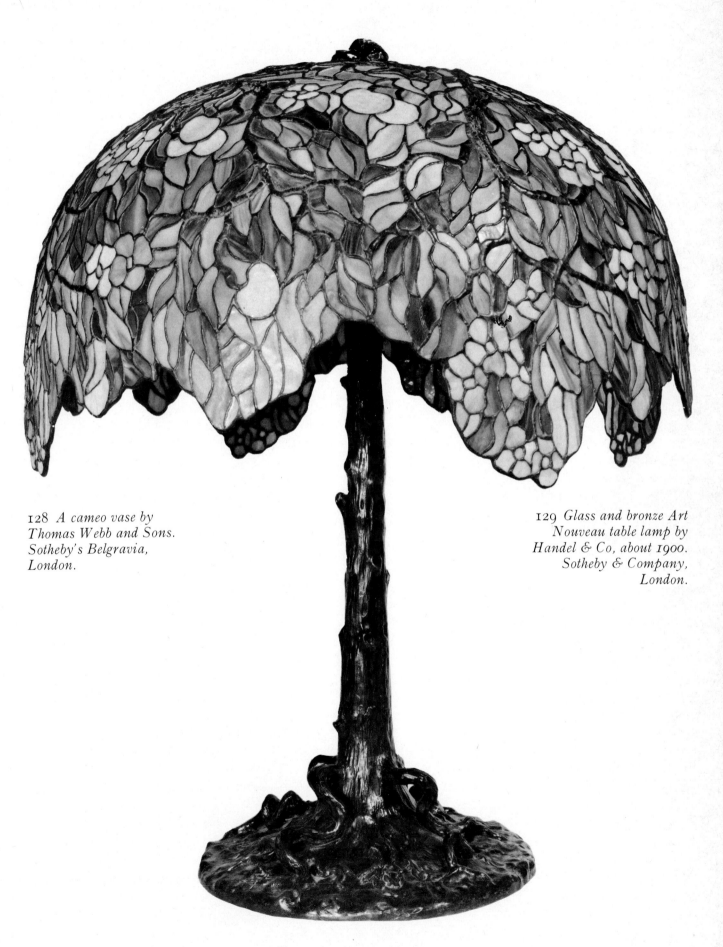

128 *A cameo vase by*
Thomas Webb and Sons.
Sotheby's Belgravia,
London.

129 *Glass and bronze Art*
Nouveau table lamp by
Handel & Co, about 1900.
Sotheby & Company,
London.

130 *Three 'Clutha' glass vases. The design on the right is by George Walton, that in the centre by Christopher Dresser, 1890s. Private Collection.*

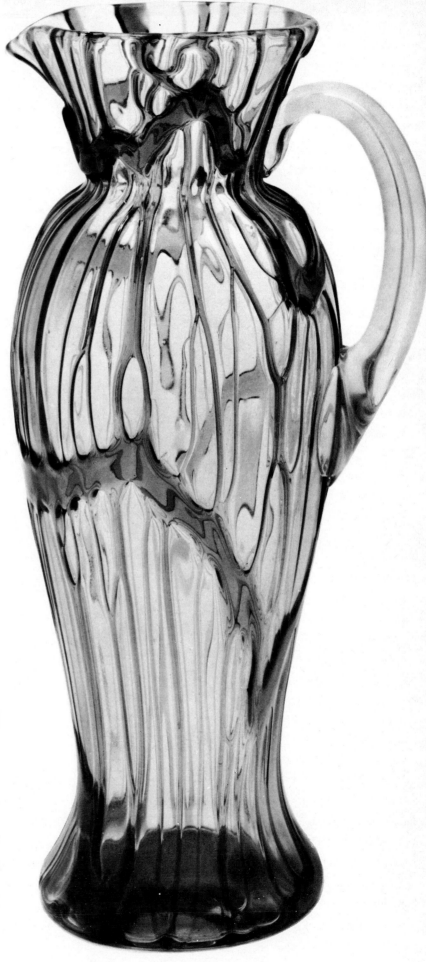

131 *Jug by Harry J.
Powell in green glass on clear.
Private Collection.*

wide range from the grand, colourful, richly lustrous charger, typical of the best productions of the Pilkington workshops, to the discreet, sensitive miniatures produced by the Martin Brothers with their emphasis on muted organic colours and forms.

The high standard of quality was maintained, in some cases ruthlessly. The Pilkington workers would systematically destroy any pieces that did not reach the standards which they fought to maintain. The Pilkington lustreware studios could afford to be strict since they were heavily subsidised by the parent firm and, in fact, often sold wares for considerably less than it cost to make them. When, added to this, one reads of the narrow success rate imposed by the

CERAMICS

By the Edwardian age a breed of potter had emerged in England and in the United States of America that had not been known for a considerable period. A general label which can be used to describe the breed is the term 'studio potters'. For once, no direct reference is intended to the magazine of that name, though its pages often promoted the products of the leading studio potters. Amongst the obvious characteristics of these new potteries was their emphasis on experimentation. They were not primarily commercial concerns (as the bad luck stories of a studio such as the Martin Brothers' confirm), but small groups of artisans working out of a genuine love for and sympathy with their medium.

As a result of this non-commercialism, the tendency was for the subtle as opposed to the gaudy. The work of the studio potters has more in keeping with Classical Oriental ceramics than with a certain type of opulent, heavily gilt traditional European ceramics.

Not that Edwardian potters were unable to be flamboyant on occasion, and their work covers a

132

vagaries of the kiln itself, it seems surprising that the studio potteries survived at all.

As far as their experiments were concerned, the Edwardian potters found certain challenges irresistible. Towards the end of the nineteenth century, potters in England, France, Italy, Hungary and Denmark were reviving the old Italian and Islamic technique of painting pottery with metallic lustre. Clément Massier, working in the South of France at Golfe Juan, was one of the first to succeed, and it was possibly the impact of the works which he exhibited at the Paris Universal Exhibition of 1879 that inspired the others. It was the particular privilege of the Pilkington works to achieve consistently out-

132 Tiles by William de Morgan, each incorporating shades of green, 1890s. Sotheby's Belgravia, London.

133 Pilkington lustre dish designed by Walter Crane and painted by Charles Ernest Cundall, depicting Bayard Un Chevalier sans peur et sans reproche, *dated 1907. Sotheby & Company, London.*

standing results on taking up this challenge in England. They were not the first in England, however, for William de Morgan had achieved his first successes in lustre contemporaneously with Clément Massier.

After 1898, the potters of Ruskinware were attempting highfired *flambé* glazes, mouth-watering colour effects, as well as intriguing effects of surface, such as irregular speckling or pitting, making their own task all the more difficult by working on an eggshell-thin pottery base of the utmost fragility.

Studio pottery was very often true to the dictum of modern design that the form of an object and its decoration should be one. The attractions of a typical piece were an integral part of it, depending if not on the shape then on the nature of the glaze itself.

These potters felt a genuine and strong passion for the dense clay, and for them, and for those who enjoy their creations, 'the medium is the message'.

The iconography of Edwardiana that has been traced throughout this study was in no way restrained from manifesting itself in pottery. We have already seen the galleon on a silver finger bowl, on a tile by William de Morgan, on a Maws dish and on a Pilkington dish. The Pilkington workshops seem eager to exploit every basic theme. The splendid peacock dish is a good example (one could almost

134,135 *Martin miniatures in salt-glazed stoneware by the Martin Brothers. The frog vase (135) is dated 1904, the other (134) is dated 1908. Private Collection.*

136 *The Martin Brothers at work. A contemporary studio photograph, 1910. Sotheby's Belgravia, London.*

134

136

135

describe the lustre itself as having a peacock sheen!)
133 as is the 1907 dish illustrated, painted by Charles
Ernest Cundall after a design by Walter Crane and
depicting Bayard *'Un chevalier sans peur et sans
reproche'* in green and red on a blue ground.

The Oriental influence on the period manifested
itself in the cult of simplicity in ceramics. An interest-
ing account of the transition from being typically
Victorian to being Edwardian in character, can be
136 observed in the work of the Martin Brothers. During
the 1870s the brothers, Wallace (sculptor), Walter
(potter), Edwin (decorator) and Charles (at first
potter and decorator then business manager), revived
the art of high-fired, salt-glazed stoneware. It was a
technique that involved critical control and timing,
and after a period of experimentation the Martin
Brothers could claim to be possibly the most
sensitive stoneware potters since Dwight of Fulham,
some two hundred years earlier.

Full credit should be given to the Doulton works
which achieved a complete mastery of salt-glazed
stoneware, and perhaps a greater control than the
Martin Brothers. Their creations, however, whose
quality was already in a decline by the Edwardian
age, have a commercial and mechanical slickness.

The Martin Brothers made pots, jugs, clock-cases,
fountains and garden ornaments decorated with
high Victorian Gothic motifs or with distinctive
grotesques, of which their series of birds is the best
known example. Their style became more delicate
and naturalistic in the last years of the century.
Business, however, was falling off, and in search of

new ideas the brothers visited Paris in 1900 for the
Great Universal Exhibition.

There they were profoundly impressed by the
organic or classical purity of the work of their
French and Japanese contemporaries. Their return
saw the beginning of a new phase in their work,
abandoning the anecdotal quality of their grotesque
subjects to become involved in problems of texture.
Many of the vases from this period are miniatures 134,135
of irregular gourd or vegetable form, some in
'mishima' technique, inlaid with clays of different
colours, with plain charcoal glazes or surfaces
resembling marrows, fish scales, lizard skin and so
forth. With the end of Edward's reign, disaster
struck the Martin Brothers, in a fire which destroyed
nearly all their stock. Charles died in 1910, Walter
in 1912, Edwin in 1915 and finally Wallace in 1923,
at the age of eighty.

When Mr W. Howson Taylor started his 'Ruskin'
potteries in 1898 he was fired with a similar fascina-
tion for the matière itself to that inspired in the
Martin Brothers, especially after 1900. The pottery
was named after that great mid nineteenth-century
apostle of 'Truth to Materials' and 'Honesty' in art–
John Ruskin; it is ironical that this trade name
acknowledging so Victorian a character should have
spanned the Edwardian age and in fact survived till
about 1933, when Mr Howson Taylor retired and the
West Smethwick works were closed. The headlines
of the *Birmingham Gazette* (Friday, 21st December,
1934), on the occasion of his retirement, describe the
personal nature of the potter's art and his devotion–
'SMETHWICK MAN REFUSES TO ACCEPT FORTUNE–
FOR A SECRET–TO KEEP PLEDGE TO HIS END.'
'FAMOUS POTTER RETIRING: NEVER TAKEN DAY OFF.'
The article goes on to discuss the offers made for the
secrets of Ruskin's delicious glazes and colours,
especially the *flambé* and *sang-de-boeuf*, and to list the 118
successes enjoyed at international exhibitions in
Brussels, Paris, Milan and elsewhere, starting with
St Louis in 1904, by this ambassador of English
pottery.

Another important ambassador was Pilkington's
'Lancastrian' lustreware: important enough to be 122,137
granted the appendage 'Royal' in 1913. This ware is
intriguing in that it employed the talents of a group
of artists, several of whose names recur in other
contexts within this study.

The Pilkington firm had already established a
reputation as tile manufacturers (Charles Annesley
Voysey produced a series of designs for the firm)
when around 1897 decorative pottery was added to
the inventory. Only in 1903 was a wheel installed so
that Pilkington's artists could decorate pieces thrown
by their own potters. Under the guidance of the
cultured William Burton, who, like the Martin
Brothers, had been most impressed by the Paris
Exhibition of 1900, the chemist, Abraham Lomax,
hurdled technical barriers to create the distinctive
hard, transparent 'Lancastrian' glaze. Over the next

few years more and more colours were added to the range that could be achieved in this lustreware. One finds ochres, yellows, oranges deepening to wine reds, fresh greens and blues and deep purples. The output was small. Fewer than ten pieces were fired per month and not all of these were passed. This was barely enough to satisfy the hungry market which included that litmus paper of the fashionable Arthur Lasenby Liberty. His eagerness would presumably have been particularly acute for pieces designed by so celebrated an artist as Walter Crane. The success of Pilkington lustreware lies in its ability to be opulent whilst maintaining a high level of originality.

The potteries described are amongst the most evocative of their period; others contributed their individual charms. The Della Robbia pottery founded in 1894 by Harold Rathbone, a former pupil of Madox Brown, produced lush colourful wares in a decorative 'aesthetic' taste; William Neatby's splendid tiles for 117 the Food Halls at Harrods date from 1902 and are pure Edwardiana. Léon V. Solon decorated pottery for Minton and hints at the close interrelation within the arts of the period when his name appears in another context as the designer for a poster for *The* 98 *Studio!*

We have seen how certain English potters learned a good deal from the French. If full credit is to be given to the French, then it must be stated that at the Chicago World Fair of 1893 the work of French ceramicists, especially Delaherche and Chaplet,

137 *A Pilkington Lancastrian dish. Decorated by Richard Joyce, about 1910. Sotheby & Company. London.*

138 *Vase of earthenware with matt deep-green glaze Made by the Grueby Faience Company of Boston, Massachusetts, about 1899. Victoria and Albert Museum, London.*

138 served as an inspiration for William Grueby. He started to use a new dense, matt glaze, and became responsible for introducing this, best known in green, throughout American potteries: according to one contemporary, Grueby-style pots sprang up 'like mushrooms after a storm'. The organic shapes of Grueby's vases, a rather heavy interpretation of French originals, are in keeping with the turn-of-the-century tendency to avoid applying decoration, but instead to allow the form and the texture to become the decoration.

This precept is well exemplified in the 'favrile' pottery of Louis C. Tiffany. Tiffany's pottery was first shown to the public in 1904 at the World Fair in St Louis (side by side with Ruskinware!) and enjoyed a limited success until about 1919. For his choice of forms, Tiffany turned to American flora and even fauna. One finds in particular pond lilies, fuschias, ferns, toadstools or tulips applied with frogs or insects, usually in one of two peculiar glazes: either a rough-splotched mossy green, or a creamy glaze with a colour-range suggesting old ivory.

Finally, two important potteries must be mentioned, linked together here by the tenuous string of their having both been founded by or for women. In 1880 Mrs Maria Longworth Nichols established the 'Rookwood' pottery. The business expanded steadily to become one of the most popular potteries in America, producing vases in forms inspired by the Orient, usually with highly vitreous glazes and colourful underglaze slip-painted decoration, often floral, but extending to such subjects as animals, negroes, details from Old Masters or portraits of North American Indians. The relevance of such themes to the medium is hard to find, but they had no difficulty in finding a market!

The Newcomb Pottery of New Orleans was created about 1895 for the pupils at the Newcomb Women's College. The young women were primarily involved in decoration of low-fired bisque wares, thrown by professional potters. Sober in form, their production has a naïve charm in its expansive lush formalised plant decoration which could perhaps be compared in style with the Della Robbia pottery made in England.

BIBLIOGRAPHY

S. Bing,
Artistic America, Tiffany Glass and Art Nouveau,
Cambridge, Mass. 1970

Bevis Hillier,
Posters, London 1969

Holbrook Jackson,
The Eighteen Nineties, London 1913

Robert MacLeod,
Charles Rennie Mackintosh, London 1968

Gillian Naylor,
The Arts and Crafts Movement, London 1971

Nikolaus Pevsner,
Pioneers of Modern Design, London 1960

J.B. Preistley,
The Edwardians, London 1970

Robert Schmutzler,
Art Nouveau, London 1962

Catalogues:

*The Arts and Crafts Movement in America
1876-1916,* Princeton University 1972

British Sculpture 1850-1914,
The Fine Art Society, London 1968

Christopher Dresser 1834-1904,
The Fine Art Society, London 1972

*Victorian and Edwardian Decorative Art:
The Handley-Read Collection,*
The Royal Academy, London 1972

ACKNOWLEDGMENTS

The author wishes to thank his sister Noelle
Garner for typing the manuscript, and his parents
for their encouragement and helpful comments;
Daniel Katz Esq. for his invaluable knowledge of
English sculpture and Tiffany glass; Simon
Stanish-Kentish and Mark Shand for allowing him
access to their reference libraries; the staff of
Sotheby's, Belgravia, and in particular John Culme
for his comments on Music Hall and musical
comedy; Antonia Wilson Clarke for her help with
research and Jeanette Kynch for her patience in
taking photographs.

SOURCES OF PHOTOGRAPHS
Black and white photographs:
Annan Photographers, Glasgow, 35; Art Institute of Chicago,
57; British Museum, 74; Bassett-Lowke (Holdings) Limited, 80;
J. Allan Cash Limited, 36, 68; Chicago Architectural Photo
Company, 40; Christie Manson and Woods, 56; Fine Art
Society, 64, 66, 67, 70; Hamlyn Group Picture Library, 39, 65,
75, 122, 138; Hamlyn Group-Hawkley Studio Associates, 27, 28,
37, 38, 44, 45, 69, 81, 82, 87, 88, 89, 90, 94, 114, 123; Heal &
Son, Ltd., 32, 33, 43; Liberty & Company Limited, 34; London
Museum, 77, 78; Mander & Mitchenson Theatre Collection, 21,
30, 93, 95; National Film Archive, 96; Pollocks' Toy Museum,
79; Radio Times Hulton Picture Library, 3, 4, 10, 41, 76, 83, 84;
Royal Institute of British Architects, 23; Sotheby's Belgravia,
7, 8, 9, 42, 46, 51, 52, 53, 55, 86, 104, 110, 113, 116, 119, 128,
132, 136; Sotheby & Company Limited, 1, 2, 5, 6, 19, 50, 60,
73, 108, 109, 120, 121, 124, 125, 126, 127, 129, 133, 137; Tate
Gallery, London, 26, 63; Victoria & Albert Museum, London,
11, 14, 18, 22, 97, 99, 100, 101; John Wannamaker 31.
Colour photographs:
Philippe Garner, 24, 62 and front jacket, 91, 92, 107;
Cooper-Bridgeman Library, 105; Daily Telegraph Colour
Library, 47, 48, 49; Hamlyn Group – Hawkley Studio
Associates, 25, 61, 85, 98, 117; Hamlyn Group – John Webb 29;
Metropolitan Museum of Art, New York, 58; Phoebus Publish-
ing Company Picture Library, 12, 13, 16, 54, 59, 102, 103 and
back jacket; Sotheby's Belgravia, 17, 20, 106.
The following illustrations have been photographed by courtesy
of: Selina Paget-Baxter and June Penn, 45, 114; Ian Bennett,
15, 111, 122, 130, 131, 134, 135; Gaby Goldscheider, 27, 28, 85;
Harrods Limited, 117; Haslam and Whiteway 69; Stephen and
Josephine Taylor, 123.
The chapter headings and tail pieces are from early editions of
The Studio by courtesy of Studio International. The title page
decorations are from a drawing by Charles Robinson for 'Alice
in Wonderland' published by Cassell and Company Limited
in 1908.

INDEX

THE END